Delmarva
Legends & Lore

DAVID HEALEY

Charleston London

The History
PRESS

Published by The History Press
Charleston, SC 29403
www.historypress.net

Copyright © 2010 by David Healey
All rights reserved

First published 2010
Second printing 2012
Third printing 2012
Fourth printing 2013

Manufactured in the United States

ISBN 978.1.59629.921.4

Library of Congress Cataloging-in-Publication Data

Healey, David.
Delmarva legends & lore / David Healey.
p. cm.
Includes bibliographical references.
ISBN 978-1-59629-921-4
1. Delmarva Peninsula--History--Anecdotes. 2. Delmarva Peninsula--History,
Local--Anecdotes. 3. Delmarva Peninsula--Biography--Anecdotes. 4. Delmarva
Peninsula--Social life and customs--Anecdotes. 5. Legends--Delmarva Peninsula.
6. Folklore--Delmarva Peninsula. I. Title. II. Title: Delmarva legends and lore.
F187.E2H29 2010
398.209752'1--dc22
2010012975

"Many a truth is spoke in ignorance and many a wrong set right by chance."

—*from* The Sot-Weed Factor *by John Barth*

CONTENTS

CONTENTS

Part III. Divided Delmarva: The Civil War

Part IV. Disasters, Shipwrecks and Mayhem

Part V. Monsters and Myths

Part VI. Ghosts, Murders and Mysteries

PREFACE

From time to time, some politician eager for the publicity or fed up with the legislature floats the idea that the Delmarva Peninsula should be declared an independent state. It's not such an outlandish concept. At 180 miles long and 60 miles wide, the peninsula is roughly the size of Connecticut, with a population that's larger than Rhode Island's or South Dakota's.

While Delaware is entirely situated on the peninsula, one sometimes wonders how hard the two other states that lay claim to Delmarva would work to keep it. Not too many years ago, the Eastern Shore of Virginia was inadvertently left off the official state highway map. Until 1896, Maryland law required that at least one United States senator representing that state had to be from the Eastern Shore. More recently, one outspoken Maryland governor referred to the Eastern Shore as an "outhouse"—hardly a term of endearment.

Independent state or not, it's clear that political boundaries on a map have little to do with real life on Delmarva. The people here have a shared history and culture that transcends state borders.

That's what this little book is about—rediscovering the sometimes quirky history of Delmarva. Some of the legends and lore collected here will be of the more familiar variety, such as the Cosden Murder Farm. But others may be less well-known secrets, such as the final resting place of noted duelist Charles Dickinson, who might have

On Delmarva, you never quite know where the path will take you. *Courtesy Clayton Perry.*

changed history if his bullet had traveled an inch deeper toward Andrew Jackson's heart. I've had a lot of fun tracking down these legends, and I hope you'll enjoy reading them.

This book would not have been possible without the help and encouragement of many people. Longtime librarian Ruth Ann Johnson and my good friend and fishing buddy Scott Lawrence shared their personal stories. Michael Dixon, that guru of all things historical, provided assistance finding photographs and giving constant encouragement. Milt Diggins shared his substantial knowledge of Thomas McCreary, and I look forward to someday reading the book he is working on about this slave catcher and kidnapper.

The Edward H. Nabb Research Center for Delmarva History and Culture was another great resource. I'd especially like to thank the photographers whose work appears on these pages. They have a real eye for history. Thanks to the librarians and archivists who helped me find some of the historical images. My editor at The History Press, Hannah Cassilly, provided great feedback and was so helpful and patient throughout the editing process. Most of all, I want to thank my family—Joanne, Mary and Aidan—for all of their support. They endured more than a few road trips as I did some historical sleuthing and then let me sneak away to my office in the attic to write.

You'll notice in these pages that I've reached far into Delmarva's past for many of the legends and much of the lore. In many cases, the events that interest us the most today were not recorded in any official way, so we are left to fill in the gaps with guesswork or storytelling. That's how real incidents evolve into legends and lore. One wonders what stories people will be telling about us in two or three hundred years.

Part I

COLONIAL DELMARVA

AUGUSTINE HERMAN: EXPLORER AND MAPMAKER

Chesapeake City, Maryland

The Maryland county Augustine Herman carved from the wilderness bears the name of his aristocratic employer, but Herman is the true founder of the Cecil County we know today.

Herman's personal history before coming to the New World remains shrouded in mystery. Some records indicate that he was born in Prague, or "Bohemia," about 1605 and then fought in the Thirty Years' War before arriving in the New World about 1629. Others say that Herman was a much younger man and that it was actually his father, a wealthy merchant turned soldier, who fought and died for King Gustav.

While his early years may be murky, there is no doubt that Herman was a well-educated surveyor and mapmaker, fluent in several languages, who played a role in the early settlement of New Amsterdam (present-day Manhattan) under Dutch governor Peter Stuyvesant. Herman amassed a fortune in the tobacco trade and owned most of the area that is now Yonkers, New York. However, Herman soon lost everything due to a political misstep. He and several other prominent men of New Amsterdam officially questioned Stuyvesant's high-handed leadership, which led to the

powerful (and notoriously vengeful) Stuyvesant becoming a lifelong enemy. He would throw Herman into prison not once, but twice.

Despite this relationship with Stuyvesant, it was Herman who was called upon in 1659 to undertake a diplomatic mission to Maryland. The Dutch were not happy that the English colony established by Lord Baltimore was welcoming former settlers from New Amsterdam into the Chesapeake region of Maryland.

It isn't really known why Herman, who had recently been imprisoned, went on this mission. Perhaps he was trying to redeem himself. Maybe Stuyvesant opted to send someone he considered expendable on a dangerous journey through the wilderness to meet with hostile Marylanders. Given Herman's restless nature, it could be that he was simply looking for an adventure.

The diplomatic mission was a failure—no one could have expected the English to bow to Stuyvesant's wishes—but Herman seemed impressed by Cecil Calvert, the Baron of Baltimore and Lord Proprietor of Maryland, and the feeling was mutual. Having had a falling-out with the Dutch, he decided to cast his lot with the English. Again and again, it seems that men who succeeded in the New World, such as Herman, were those who had the ability to reinvent themselves and take chances.

Ever an opportunist, Herman offered to map the Chesapeake region for Lord Baltimore. He personally explored the peninsula, and the resulting 1670 map was so detailed that it would be used for more than a century as the definitive geographical guide. Herman was also clever enough to include a self-portrait on the map, and this likeness survives today.

As a down payment for this service, Lord Baltimore gave Herman four thousand acres north of the Bohemia River. Upon completion of the map, Herman was given a total of fifteen thousand acres, reaching all the way to the Delaware Bay. Herman would eventually come to own thirty thousand acres, much of it on the Delmarva Peninsula, making him the largest landowner in North America after the likes of Lord Baltimore and William Penn.

It was Herman who first urged the powerful Calvert family to create Cecil County at the top of Chesapeake Bay. At the time, it was part of Baltimore County. Herman became one of Maryland's

leading citizens and settled on a plantation called Bohemia Manor. In 1661, he proposed routes for digging a canal across the Delmarva Peninsula. It would be 150 years before that concept was realized and the Chesapeake and Delaware Canal was dug; Herman's ideas were just ahead of their time. Herman was declared "lord proprietor" of his lands, with the power to give grants of property as he saw fit to encourage settlement. For this reason, Herman is sometimes mistakenly believed to have been an aristocrat, although he was certainly the "lord of Bohemia Manor."

Perhaps the greatest legend surrounding Augustine Herman has to do with his incredibly daring escape from a second imprisonment at the hands of Peter Stuyvesant and the Dutch. At some point, probably about 1663, Herman returned to New Amsterdam. He must have realized the risks of returning to a Dutch colony that considered him a spy and traitor for casting his lot with the English. The reasons for this dangerous homecoming aren't entirely known, but it's likely that with Dutch power waning in the New World and the English on the rise, Herman might have been trying to regain ownership of his old property in New Amsterdam.

Herman was arrested, jailed and sentenced to death upon his return. While in prison, Herman requested that he be allowed to ride his horse, Gustavus, around the governor's walled compound for exercise. It wouldn't have been all that unusual for a wealthy and prominent prisoner to be allowed such special privileges. The guards became accustomed to his daily rides and less watchful.

According to an 1895 account in the *New York Times*, Herman feigned madness so that the Dutch soldiers would not take him as a serious risk. As the date for his execution approached, Herman startled his guards one day by riding his horse into a banquet hall and crashing through a window to escape. Horse and rider plunged fifteen feet to the ground and then swam the North River. The angry guards were soon in pursuit. Herman galloped the length of New Jersey, pushing Gustavus so hard that blood streamed from the horse's nostrils, but the horse never faltered. Finally, they reached the Delaware River and safe passage to Maryland.

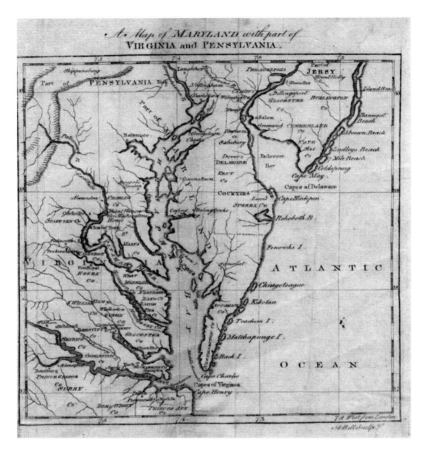

A map of the Delmarva Peninsula made in 1781, when the colonies were still struggling for freedom from England. *Courtesy Delaware Public Archives.*

Out of gratitude for saving his life, Herman never rode Gustavus again, and when the horse died, Herman had him buried in the family cemetery. Herman even had a portrait painted of himself with the horse. Sadly, that portrait may have existed in the family as recently as about 1870 but has since disappeared.

Herman died in 1686—apparently having lived to the ripe old age of eighty-one—and was buried with his beloved horse on one side and his wife on the other. Today, Route 213 in Cecil County

is named Augustine Herman Highway, and the Chesapeake City high school building is called Bohemia Manor. Herman's name is otherwise largely forgotten, but more than anyone else he can be said to have literally put the Delmarva Peninsula on the map.

CHESTERTOWN TEA PARTY

Chestertown, Maryland

Every spring, at the Chestertown waterfront, townspeople reenact an event that displayed their independence from King George III.

"Boo to the British!" cries a spectator, applauding as a rowdy band of men and women wearing colonial garb swarms down High Street to the Chester River. The reenactors pile into boats and row out to the tall ship *Sultana*, where they proceed to take over the ship and throw British tea into the river.

Known as the Chestertown Tea Party, it is cause for a huge town festival that draws visitors from all across Delmarva. Chestertown, with its stately colonial-era houses and brick sidewalks, doesn't look all that different from how it appeared on May 23, 1774, when the real protest supposedly took place.

While the houses and streets were here, along with at least one British ship filled with tea, what's not as certain is whether colonial-era townspeople really took matters into their own hands with this act of insubordination.

The more famous Boston Tea Party occurred on December 16, 1773, when patriots dressed as Indians (to disguise themselves) and boarded three ships in Boston Harbor to toss tea overboard. This outrageous action was taken to protest the Tea Act, passed by Parliament in 1773 to keep the royal coffers full. (Some colonists launched a more passive-aggressive protest by drinking coffee instead, helping to make it a popular beverage in the colonies.)

King George III reacted by ordering the port of Boston to be closed, an action that did nothing to endear him to the colonists. Soon enough, the colonies would be in full rebellion against the Crown.

In Chestertown, news of the Boston protest prompted the local Sons of Liberty to create the "Chestertown Resolves." Basically, this measure outlawed British tea in town.

While the "Chestertown Resolves" were real enough, there doesn't seem to be any proof that angry rebels boarded the British merchant vessel *Geddes* at the time. Did Chestertown patriots really follow the example of Boston's Sons of Liberty? Some suspect that it might all have been angry tavern talk fortified by the sort of liquid courage that quickly dissipated when it came time for action. But it does seem likely that something like the Chestertown Tea Party did take place, considering that the legend has endured for more than two hundred years.

HOW WHOREKILL AND MURDERKILL GOT THEIR NAMES

Lewes, Delaware

There's nothing like a day at the beach. Pack the sunscreen and some sandwiches, load the kids in the car and head down Route 1 for the Delaware shore. For visitors from points north, the closest beaches can be found in the quaint town of Lewes and especially the state park at Cape Henlopen.

At first glance, these are picture-perfect beach destinations straight out of a tourism brochure. What the brochure would surely fail to mention is Lewes's violent and bloody origins and its rather unsavory original name of Whorekill.

Your first clue to some unsettling business from the past might very well have been some other place names you noticed on the trip down Route 1. In the vicinity of Killens Pond State Park south of Dover, you might have seen that you were crossing the Murderkill River, just up the road from Slaughter Beach.

Whorekill? Murderkill? Slaughter Beach? Yes, the legends behind these Delaware place names are pretty much the ones that your imagination just provided. Maybe even worse.

The origins of place names sometimes present a puzzle. Names get passed down generation after generation, but the reasons for them don't always make it. But do a little digging, and the origins usually come to light, although there is sometimes a bit of guesswork and deduction involved when trying to figure out what was on the minds of European settlers from the 1600s.

One of the most sinister names, Slaughter Beach, is hardly appropriate for the friendly community there—that is, unless you happen to be a horseshoe crab. Local legend says that the name may stem from the annual springtime appearance of hordes of horseshoe crabs that emerge from the waters of Delaware Bay to lay their eggs on the beach. Changing tides leave many crabs stranded, so that they fall victim to the beating sun or marauding foxes and raccoons—hence the name "Slaughter Beach." (There is a less gruesome theory behind this interesting place name, which is that it comes from William Slaughter, a local postmaster who lived at the beach in the mid-1800s.)

The legends behind the Murderkill River and Whorekill are far bloodier. Don't be entirely reassured by the fact that "kill" is a Dutch word for "river" or "creek." The Dutch were the original settlers of much of what is now Delaware, Pennsylvania and New York, so it's not unusual to find rivers bearing the name "kill." The Schuylkill near Philadelphia is one of the best-known examples, although it roughly translates from the original Dutch as "Hidden River," probably due to the dense vegetation along its banks when it was first mapped in the 1600s.

The origins of "Whorekill" are murkier. Dutch explorers first arrived at what is now Lewes in 1629 and purchased land from the Siconese Indians who lived there. Long before it was dredged to create the Lewes-Rehoboth Canal, the river there was named "Hoerekill" in Dutch. The Dutch word "hoere" means whore ("hoeren" in the plural). In other words, Harlot's River.

Considering that a Dutchman's "hoere" was an Englishman's "whore," how did the river get this rather X-rated name? Historians say it apparently has something to do with the tradition of Siconese men sharing their women as a gesture of friendship to the Dutch. Your average Dutchman probably thought this was a fine way

to celebrate a purchase of the Indians' land and a memorable place name, but the "hoeren" in question soon led to cultural misunderstanding and massacre.

In 1631, the Dutch left behind settlers to establish a whaling colony on the Hoerekill. Sometime that year, perhaps in a dispute over the Dutch treatment of the women they had shared, Siconese warriors descended on the settlers and killed them all. Considering that the Siconese were considered to be very peaceful, it does seem likely that they were provoked.

The Dutch were appalled by the massacre, and it would be many years before the settlement on the Hoerekill was reestablished. When the Dutch returned, they had their revenge in an incident that would lead to another brutal place name.

According to *Names on the Land: A Historical Account of Place Names in the United States*, here is how the Murderkill got its name:

> [R]emembering how they had been served at the *Whore-Kill*, [the Dutch] *went some ten or twelve miles higher, where they landed again and traded with the Indians, trusting the Indians to come onto their stores ashore, and likewise aboard their sloop drinking and debauching with the Indians until they were at last barbarously murdered, and so that place was christened with their blood and to this day is called the Murder-Kill, that is, Murderer's Creek.*

As for Hoerekill (or Whorekill), the village there continued to be called by that name (or sometimes Zwaanendael) until 1682, when William Penn assumed ownership of the region and redesignated it with the more puritan name of Lewes, after the English town in East Sussex. All these years later, the name Lewes still sounds better in the tourism brochures, but its bloody past hasn't entirely been forgotten.

LOST HOUSES OF DELMARVA

When Augustine Herman, the mapmaker and fugitive Dutch patroon who would become Delmarva's largest landowner, arrived

in the Chesapeake wilderness in the 1600s, it's likely that he built what came to be known as a "Sorry House." This simple post-and-beam construction was intended to be a basic shelter from the elements (and the animals). As an explorer and former soldier, Herman probably took the added precaution of enclosing his modest house and other buildings inside a log fort in case of Indian attack. The grand residence that would earn him the title "lord of Bohemia Manor" would be years in the future.

Any trace of Herman's original four-hundred-year-old log dwelling is long since gone. His experience gives a clue to what remains one of the great mysteries of early Delmarva. We know that the area was settled by Europeans even before Herman's arrival, making it one of the oldest settled areas in the United States. So where are all of the old houses?

Only a handful survive. One of the oldest houses in Delaware is the Block House in Claymont, built in 1654 by the last governor of New Sweden. In 1671, the modest stone dwelling—part fort and part house—was attacked by Indians. Another of the oldest houses

Bound's Chance, an early Maryland house, as it appeared in 1968. *Photo by Michael O. Bourne. Courtesy Maryland Historical Trust.*

in Delaware is the Ryves Holt House located on Second Street in Lewes. The Lewes Historical Society, which owns the house, says that it was built in 1665 by the Dutch founders of the town known then as Zwaanendael.

Travelers in the late 1600s came across two men who were building a tavern on the road between Appoquinimink Creek in present-day Delaware and the Bohemia River in Maryland, as recounted in the architectural and cultural study *At the Head of the Bay: A Cultural and Architectural History of Cecil County, Maryland.* Their description provides a glimpse of the harsh conditions faced by settlers trying to carve out a life on the Delmarva frontier.

For shelter, the men built

> *a shed, made of the bark of trees, after the manner of the Indians, with both ends open, and little larger than a dog's kennel, and where at the best* [three men] *might possibly have been able to lie, especially when a fire was made…He had nothing to eat but maize bread which was poor enough, and some small wild beans boiled in water; and little to lie on, or to cover one, except the bare ground and leaves.*

What those travelers encountered helps explain, in part, why there are so few early houses found on Delmarva compared to New England. Only a handful of houses here date to the 1600s. It wasn't that there were no European settlers, but rather that their existence was far more tenuous than we might expect. Hundreds of years before modern medicine and air conditioning, the Chesapeake was considered by settlers from cold, old Europe to be a tropical climate, full of fevers, mosquitoes and vast marshes.

There were other hazards besides the climate. Where there wasn't marsh, virgin forest grew thick to the water's edge. It wouldn't have been all that unusual for early Europeans wandering this primeval forest to encounter wolves, bears or even panthers. Don't forget the snakes, either; fortunately, the poisonous ones are rare on Delmarva, although the swamps on the lower peninsula had their share of deadly cottonmouths.

Indian wars are less well known on Delmarva, but conflict did occur. In 1661, for example, a band of Delaware Indians attacked

and killed four Europeans in what is today New Castle County near Iron Hill, setting off a minor war. Also in what is now Delaware, the Swedes and Dutch were almost constantly at war over control of a vast New World territory that one side called "New Sweden" and the other claimed as "New Amsterdam."

The climate, wilderness conditions and violent conflict combined to discourage permanent settlement on what was then called the Chesapeake peninsula—the future states of Maryland, Delaware and Virginia.

According to the Maryland Historical Trust experts, just five structures in the Chesapeake region survive from prior to 1700. All were substantial houses for their day compared to the average dwelling.

The majority of houses did not survive the intervening centuries. Most settlers built small, practical homes like Augustine Herman's original house—a one-story dwelling with one or possibly two rooms downstairs, a fireplace and a sleeping chamber above. These houses did not have stone or brick foundations but rather were built

Many of the truly old houses on Delmarva have disappeared over time. *Courtesy Maryland Historical Trust.*

around posts sunk into the ground. Even when the builder bothered to use locust or cedar posts, these rotted over time. It didn't help that the houses were not well maintained; early settlers were focused on wringing a living from the land. A house was considered to be rudimentary shelter until something better could be built.

Seen in that light, it's easier to understand why early Delmarvans left so little behind. It wasn't until the early years of the eighteenth century that the wealthiest settlers—those who had survived the rigors of the region known as the Chesapeake—began to build the elegant brick houses that still stand today.

You might call these plantation mansions the "second generation" of housing on Delmarva. The very oldest have simply rotted away.

WILLIAM CLAIBORNE: CHESAPEAKE BAY'S FIRST PIRATE

Kent Island, Maryland

If there was a single man who caused more conflict than any other in the earliest days of Delmarva, it was certainly William Claiborne. The man who would come to be known as Chesapeake Bay's first pirate and outlaw was born about 1600 in Kent, England, and journeyed to the New World as an ambitious young surveyor and entrepreneur. Claiborne soon became one of the most prominent and controversial leaders in Virginia or Maryland. His actions would brand him as a brigand and troublemaker, a reputation that has survived for four hundred years. The question is: does Claiborne deserve this lingering ill repute, or has he simply been misunderstood?

A surviving portrait of Claiborne shows a dashing man who has all the appearance of an English cavalier: long, dark, wavy hair; a Vandyke mustache and beard; and, perhaps most telling of all, he happens to be wearing armor. The portrait matches well with the legends of Claiborne's swashbuckling adventures.

Brash and outspoken by nature, Claiborne seemed to have both a knack for success and an ability to rub people the wrong way. He was the proverbial bull in the china shop of colonial Delmarva. His real troubles began when he essentially found himself on the wrong

side of the English political factions and intrigue that were busy dividing up the New World.

In 1631, Claiborne sailed for Kent Island in modern-day Queen Anne's County, Maryland, to establish a trading post. At that time, the region was still considered part of Virginia. Claiborne's plan was to take advantage of the booming business in furs, then much in demand in Europe, by trading with the Indians. Kent Island on Chesapeake Bay was ideally located for this enterprise. Venturing farther north, he established a trading post at Palmer's Island (modern Garrett Island, which anchors the Route 40 bridge) at the mouth of the Susquehanna River in Cecil County. The northern island gave him even better access to furs from tribes such as the Susquehannocks. In no time at all, hundreds, if not thousands, of valuable beaver pelts were passing through Claiborne's hands.

Then disaster struck for Claiborne when the first Lord Baltimore received a grant for the new colony of Maryland. Claiborne, a staunch Virginian and Protestant, found that his burgeoning business and land were no longer located in Virginia but in Maryland, under the proprietorship of a Catholic baron.

Trouble began in 1635 when Marylanders under the command of Thomas Cornwallis encountered one of Claiborne's trading ships in Pocomoke Sound and captured it after a short fight. Although they were all Englishmen, the fact that Claiborne's vessels were operating in Maryland waters without proper sanction was his way of blatantly thumbing his nose at Lord Baltimore's authority.

Enraged, Claiborne mounted an expedition of Virginians and attempted to recapture the vessel. He failed, and a total of three Virginians died in these first naval battles in North America.

Claiborne apparently intended to have his revenge. In 1637, Claiborne's men at Palmer's Island spotted a Maryland vessel sailing in the Susquehanna River. They attacked and captured the ship, seizing its cargo and taking the crew prisoner. This time, it wasn't a battle between rival colonies but an attack by a privately owned ship on a merchant vessel, thus making it the first act of piracy on the Chesapeake. Even though Claiborne had not personally taken part, angry Marylanders soon branded him as a pirate. Later that year, while Claiborne was in England whispering poison against

the Calverts in the ears of the Cromwell-led government, a force of Marylanders captured Kent Island and arrested the leaders of Claiborne's rebellious Virginians.

That wasn't the last bid for Kent Island that Claiborne would make. In 1645, Claiborne took advantage of the political confusion and power vacuum created by the fall of the monarchy to invade his old turf. But in 1646, Maryland governor Leonard Calvert regained control by military force.

Claiborne saw his fortunes improve under Cromwell's Protestants, who were no fans of the Catholic Lord Baltimore. Incredibly, the year 1655 saw fighting between Protestants and Catholics in Maryland, culminating in a March 25 battle on the Severn River.

With the restoration of the monarchy, though, the colony of Maryland was returned to the proprietary control of the aristocratic Calvert family. Claiborne had been a staunch supporter of Cromwell and Parliament and so found himself with few friends and little influence in England. Although he signed a peace treaty with the Calverts in 1657, he finally abandoned his claims in Maryland and settled for good on a vast five-thousand-acre estate on the Pamunkey River in Virginia, where he died in 1677.

If Claiborne had been more pragmatic, he might simply have accepted the changes in the boundaries that placed his former Virginia lands in Maryland, paid his respects and taxes to Lord Baltimore and gotten on with growing his business. But that was not Claiborne's nature. He seemed to think that he could make his own rules in what was then the wilderness of the Chesapeake, which is why today he is remembered as a pirate and rebel.

BALTIMORE VERSUS CHARLESTOWN

Charlestown, Maryland

Charlestown today is a sleepy village on the shores of the upper Chesapeake Bay, but what many visitors might not know is that more than two hundred years ago this town was founded to rival Baltimore as Maryland's major port of trade.

If one looks closely here, pigs can be seen strolling the dusty streets of Charlestown in the 1800s. Colonial speculators once hoped that the town would rival Baltimore as the Chesapeake Bay's port city. *Courtesy Historical Society of Cecil County.*

At first glance, the very idea might seem preposterous. How could this tiny crossroads ever have hoped to become not just Delmarva's largest city, but one of the largest in colonial America? Yet when one looks more closely at what Charlestown had going for it when the town was founded in 1742, it's not such a stretch of the imagination. In fact, you might say that it was fate—in the form of one of Chesapeake Bay's largest hurricanes ever recorded—that dampened Charlestown's ambitions.

Looking back to colonial times, it's important to keep in mind that many of the young nation's most important cities were conceived as nothing more than lines on a map. (The city that would become Washington, D.C., might be the most famous example, having been laid out on swampy vacant ground near the Potomac River.) Some cities grew around a strategically important fort or busy crossroads,

but rivers and bays were the superhighways of the 1700s. One location had almost as good a chance as another if it was located on the water.

A 1742 map of Charlestown shows a carefully planned town laid out in a grid pattern with more than three hundred lots and space reserved along the Northeast River waterfront for wharves and storehouses. Four lots were reserved for the county courthouse established there. There was a spacious town green akin to those in New England towns where militia could drill and sheep could graze. Like any ambitious town of its day, Charlestown was named in honor of the Lords Proprietor of Maryland, in this case Charles Calvert, fifth Lord Baltimore.

The town had an ideal location, too. It was on the busy overland route that connected Virginia and Philadelphia. From there, it could receive wagonloads from farmers growing prosperous from the booming grain business. Located at the top of Chesapeake Bay, the town was basically the northernmost point that ships could travel, enabling an easy connection between farm goods and shipping. According to *At the Head of the Bay*, Charlestown exported grain and salted fish (mainly herring and shad) to the West Indies. Ships then returned with rum, sugar, slaves and immigrants to the colonies.

Several prominent businessmen shared the same vision for Charlestown's future. They built fine houses on the clustered streets, creating an urban environment on the edge of farm country. Among the early settlers and promoters of Charlestown were John Paca, father of Declaration of Independence signer and future Maryland governor William Paca; Francis Scott Key's grandfather, Francis Key; Governor Thomas Bladen; and Revolutionary War hero and congressman Nathaniel Ramsey.

These and other men built homes in Charlestown. There is the 1745 Hamilton House on Lot 74, named after Reverend John Hamilton, who apparently bought the house as a safe investment in an up-and-coming town, and the Tory House built in 1750. One of the more curious houses is the Still House, circa 1760, where raw sugar from the West Indies was made into rum. At the time, it was the only rum distillery in the region, and Charlestown became known for both serving and drinking rum. As many as ten taverns and inns operated in Charlestown at the height of its boom.

Considering that the town was awash in rum, ships' captains and sailors with full pockets, it's no surprise that there must have been some good times. In the 1700s, the town passed an ordinance banning a popular sport among the youths of the town. The disruptive pastime was a form of urban bowling that involved rolling cannonballs through the streets.

Charlestown's chief rival was Baltimore, founded in 1729 and named in honor of Cecilius Calvert, then the reigning Lord Baltimore. Hard as it may be to believe today, Baltimore's success as a port was not a given. Although it was larger than Charlestown, the booming port in Cecil County might have outstripped the town on the Patapsco River.

Like Charlestown, Baltimore was primarily a port for the export of grain. Then came that act of fate in the form of a Chesapeake Bay hurricane. Anyone who has lived on Delmarva for any length of time knows that these storms can wreak terrible havoc here. The same was certainly true for Charlestown. Along with high winds, rain and flooding, these storms bring flood tides and savage currents that can literally alter a waterway. When the storm subsided, Charlestown's once-booming port was badly silted in, taking away its deepwater access for oceangoing ships.

There is some debate about which hurricane did in Charlestown. The date of 1786 is often given, but records show no hurricanes for that year. Instead, it was most likely the Great Chesapeake Bay Hurricane of 1769 that did Charlestown irreparable harm, with tidal surges of up to twelve feet.

Hurricane seasons tend to run in cycles, and the 1700s were a time of unusual hurricane activity. Charlestown could have been affected by any of these storms, including major hurricanes in October 1743, October 1749, the aforementioned 1769 storm, the "Hurricane of Independence" in 1775 or hurricanes that struck the Chesapeake again and again in 1780, 1785, 1788 and 1795.

The sum total of these storms was that Charlestown found itself surrounded by increasingly shallow water. Baltimore had been spared the same fate, and by 1790 that town's population reached 13,503. (Charlestown's population is today just over 1,000.)

The town that had been up-and-coming gradually became a backwater. Ships sought other ports. The inns closed, and the

famous distillery was dismantled. Even the Cecil County Courthouse decamped for the faster-growing town of Elkton. Some pragmatic merchants packed up and moved to Baltimore, literally taking apart their dwellings and storehouses and then re-erecting them in Charlestown's rival. In what may have been the ultimate indignity, Charlestown's most famous resident, Nathaniel Ramsey, became chief officer of the Port of Baltimore in 1794.

Charlestown has lived on and remains one of Delmarva's oldest self-governed towns, but its vision was never fulfilled. In the late 1700s, one smug critic scoffed, "What, I beseech you, is Charles town?—a deserted village, with a few miserable huts thinly scattered among the bushes and crumbling into ruin." Storm-battered and weedy, Charlestown's dramatic growth had long since halted and its high hopes dashed.

THE ORIGINAL SOT-WEED FACTOR

Dorchester County, Maryland

Long before it was a novel by award-winning author John Barth, the original "Sot-Weed Factor" by Ebenezer Cooke was a none-too-flattering narrative poem about early Maryland and an unsuccessful dealer in sot-weed (1600s slang for tobacco). A "factor" was a merchant who traded in tobacco.

"The Sot-Weed Factor Or, A Voyage to Maryland" stands out as an honest (and humorous) satire of early Maryland at a time when other literature read more like promotional copy from a time share sales brochure intending to make the New World sound inviting to would-be settlers. Cooke's description of Maryland might have been enough to keep them at home.

Published in 1960, Barth's novel helped to establish his reputation as a literary star. His picaresque story chronicles the adventures of a rather naïve newcomer to Maryland. In fact, young Ebenezer Cooke is something of a Delmarva version of Voltaire's Candide.

While Barth took more than a few fictional liberties in creating his story and character, the fact remains that Ebenezer Cooke was

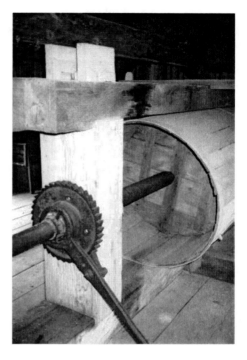

Tobacco was the main crop of early Maryland, but it was not a business that was kind to inexperienced traders, as the writer of the original "Sot-Weed Factor" poem discovered. Shown here is the machinery inside a tobacco prize house on the Sassafras River, where the sot-weed was pressed into barrels for shipment to England. *Courtesy Historic Mount Harmon Plantation.*

not only a real person but also a talented poet and observer of early Maryland life.

Not much is known about the real-life Ebenezer Cooke. In addition to having a name that's wonderfully reminiscent of Ebenezer Scrooge, he seems to have been born about 1670 to a well-off family and was educated at Oxford. Like so many adventurous young gentlemen who made their way to colonial Maryland, it is likely that he was a younger son with limited prospects at home. He must have hoped to make his fortune in the New World.

For an educated young man arriving in Maryland in the late 1600s, the rough frontier life must have been a rude awakening. In his narrative, Cooke detailed the horrible food, sickness, poverty, sexual promiscuity, drunkenness and rough ways of early Marylanders. It was a world in which newcomers were often taken advantage of—as Cooke soon discovered when he tried to set himself up in business as a tobacco trader. Simply put, Cooke

did not portray himself as the sharpest businessman and found himself taken in again and again by colonial-era flimflam artists and confidence men. We can assume, for the most part, that Cooke recounted his actual experiences and adventures.

If he didn't start out as an astute businessman, Cooke's education did serve him well as a poet. Written in short couplets, his "Sot-Weed Factor" is easy to read and entertaining even today.

In the following, Cooke describes his first night in Maryland (after being put to bed in a drunken state by a woman he mistakes for a harlot):

> *Hoarse croaking Frogs did 'bout me ring,*
> *Such Peals the Dead to Life wou'd bring,*
> *A Noise might move their Wooden King.*
> *I stuff'd my ears with Cotten white*
> *For fear of being deaf out-right,*
> *And curst the melancholy Night.*

He also writes about "seasoning," the process by which a European's body becomes acclimated to the diseases and subtropical summer climate of Maryland, sort of like a severe case of jet lag that lasts for months:

> *I felt a Feaver Intermitting*
> *A fiery Pulse beat in my Veins,*
> *From Cold I felt resembling Pains*
> *This cursed seasoning I remember*
> *Lasted from March to cold December.*

According to literary sleuths, Cooke's misadventures in Maryland convinced him to return to London. He published "The Sot-Weed Factor" there about 1708. The publication couldn't have won him many friends at home, where pamphleteers were trying to achieve just the opposite of Cooke's poem by singing the praises of Maryland in order to lure settlers and business enterprises.

The poem was sufficiently popular to launch a modest literary career for Cooke, who went on to write other poems (notably elegies)

that documented the lives of prominent men. As a poet, Cooke was adept at combining art with commentary about the people and events of his day.

Cooke's story doesn't end in London, however. Against all odds and perhaps his better judgment, he returned to Maryland about 1717 upon inheriting land in Dorchester County. Older and wiser, he seems to have been a more capable businessman the second time around. Even more interesting is the fact that, later in life, Cooke actually turned his writing skills to the very sort of boosterism that had lured him to the colony under false pretenses as a young man. The mystery remains. In spite of himself, did Cooke actually come to have a love for Maryland?

Cooke died on the Eastern Shore in 1732. He never became wealthy or prominent, but by all accounts he was well respected and achieved a comfortable upper-middle-class life through successful business dealings that had eluded him as a sot-weed factor.

Let's allow Ebenezer Cooke to have the final word in warning travelers away from early Maryland:

> *To touch that Shoar, where no good Sense is found,*
> *But Conversation's lost, and Manners drown'd.*

BLOODY DELMARVA: ENGLISH, SWEDES, DUTCH AND NATIVE AMERICANS IN CONFLICT

When it comes to the violent history of the Delmarva Peninsula, you might say that the trouble began on a fair-weather day in 1524, when Giovanni da Verrazano landed in the New World and promptly abducted a young Indian boy.

Verrazano and his men tried to capture an attractive Indian woman as well—probably the boy's mother. This attempt is recounted in *Maryland: A Middle Temperament*: "We did try to take the young woman (which was very beautiful and of tall stature), they could not, possibly because of the great outcries that she made." Considering that the sailors had been at sea for some time, it's easy to imagine their disappointment that she got away.

Swede Rocks on the Christina River in northern New Castle County, Delaware, where Swedish settlers landed on March 29, 1638. While Swedish and Dutch settlers all tried to secure at least a piece of the peninsula, it was the English who eventually won total control. *Courtesy Delaware Public Archives.*

The next European man to appear on the Eastern Shore, by most accounts, was an Englishman named Bartholomew Gilbert. The fact that his name is relatively unknown today may have something to do with a brief career that came to an abrupt end at the point of a spear. In 1603, he came looking for Sir Walter Raleigh's ill-fated colony of Roanoke and ended up in Chesapeake Bay. Gilbert took a party of men ashore and was promptly ambushed by Indians and killed, along with two sailors. Such violence was really not typical of Eastern Shore Indians. Some anthropologists have speculated that stories of Verrazano's mistreatment had become widespread and were perhaps exaggerated over time, so that the Indians reacted violently to the reappearance of new explorers. Who could blame them?

For a peninsula that prides itself today as a gentle region, where the most violent act you might witness involves cracking a crab shell with a wooden mallet, Delmarva has an almost secret history of war and conflict. Indian versus European. Marylander versus Virginian. English versus Dutch. Black versus white. Even waterman versus waterman in an Old West–style gunfight over the right to harvest oysters. You can hardly round a bend in the road or sail past a point or "neck" without passing the site of some violent travesty from the past—it's just that you aren't as likely to find a historical market there summarizing events in black and white.

When European settlers began to arrive en masse in the 1630s, they immediately began to push the Indians off their ancient and ancestral lands. The Indians did not go quietly. For instance, in 1631 the Dutch established a whaling village at what is now Lewes. When supply ships returned in 1632, the village and all of its inhabitants were gone—massacred by the Siconese Indians.

Indian conflicts flared up again in 1659 when an English settler named Edmund Scarburgh launched a war of attrition against the Assateagues, who occupied much of the lower peninsula. Scarburgh led an expedition of three hundred men, sixty horses and several sloops. In his assessment, it was much "harder to find than conquer" the elusive Assateagues. Scarburgh's expedition went against government policy, but he and other settlers took matters into their own hands because they disliked and mistrusted the natives.

Violence between whites and Indians wasn't limited to the lower peninsula. In 1661, growing tension between the Delawares and settlers led to clashes in what is today Cecil County. In the vicinity of Iron Hill at the Cecil County–New Castle County line, a party of Indians attacked and killed four unsuspecting white travelers in retaliation for a previous unprovoked attack on the Delawares. Soon, the uneasy peace between whites and Indians had been transformed into a full-scale war from the Bush River in Baltimore County, Maryland, all the way across today's state of Delaware. Lord Baltimore finally met with the chief of the Delawares at the village of Appoquinimink near modern Odessa, Delaware, and brokered a peace treaty.

Unfortunately for the Indians, their power was declining due to the spread of smallpox and other diseases. With no natural immunity to these European diseases, whole villages were wiped out. It is estimated that thousands upon thousands of Delmarva Indians perished from disease in the final decades of the 1600s, bringing their once-proud culture to ruin. This genocide on the part of Europeans was unintentional, but they certainly didn't mind the outcome.

The waning of Indian power hardly meant the end of conflict, because more than one group of Europeans sought to control the vast peninsula. Great fortunes were at stake—not just among nations, but also between countrymen divided by religion or commercial alliances.

In 1635, a naval battle at Kent Island took place between Virginians led by William Claiborne and Marylanders for control of Chesapeake Bay. (Marylanders lost the battle, but Lord Baltimore's political influence back in England won the war.)

On December 24, 1673, Maryland troops attacked and burned the Dutch village that had sprung up at Zwaanendael (modern Lewes, Delaware) on the Delaware Bay. The last thing Marylanders wanted was a Dutch foothold on the peninsula. By the 1700s, however, Lord Baltimore would lose what is now Delaware to William Penn—founder of Pennsylvania. At that time, Maryland troops mustered on the northern reaches of the peninsula for fear of an invasion of Pennsylvanians. George Talbot, Lord Baltimore's agent in Cecil County, murdered the king's tax collector in an

argument over whether residents in the upper peninsula owed allegiance to Lord Baltimore or William Penn. (Talbot was later pardoned for the crime.) A high point in Cecil County was designated as "Beacon Hill," a spot from which a signal fire could be lit to warn Marylanders. We know it today as Bacon Hill on Route 7.

As control of the peninsula began to resolve itself in the colonial era, Delmarva residents found themselves caught up in national conflicts. Though largely untouched by the French and Indian War—except effecting a suspicion of Catholics—the Revolutionary War left Delmarva deeply divided between Patriots and Tories.

Few Eastern Shore residents, however, could muster sympathy for the British during the War of 1812. During what is sometimes called the Second War of Independence, the Royal Navy raided at will up and down both the Chesapeake and Delaware Bays, putting towns and farms to the torch. Except for the Battle of Caulk's Field during August 1814 in Kent County, American victories were few and far between, while suffering at the hands of the invaders was abundant. Just ask the residents of Lewes or St. Michaels or Georgetown on the Sassafras how they feel about the redcoats.

The Civil War was no less painful, with brother once again pitted against brother. Delmarva mostly escaped direct warfare, except for some skirmishes between loyal Confederates on Virginia's Eastern Shore and Union troops early in the war.

Some of the bloodiest battles in modern times, though, were fought over the humble oyster. During the 1800s, with prices for the bivalve booming, watermen converged on the Chesapeake Bay to fight over the choicest oystering grounds. A shooting war broke out once again between rival Marylanders and Virginians, with deadly results. In the winter of 1889, it is said that a dozen oystermen were killed on the oyster-rich Hog Island Flats alone.

Delmarvans remain a feisty bunch, especially if you've ever witnessed a town meeting. Fistfights have broken out at more than one town council proceeding concerning hot-button issues such as water rate hikes and noisy backyard chickens. Fortunately for those of us who live here today, however, life on the peninsula seems to have settled down for the most part, with territorial rivalry reduced to which town's restaurants offer the best crab cakes.

DEBTORS' PRISONS

Accomac and Eastville, Virginia

We've all been a little late on our bills at times (maybe even more than a *little* late). In eighteenth and nineteenth century Virginia, instead of getting a polite letter reminding you that you must have "forgotten" a payment, the sheriff would arrive to escort you to jail—or gaol, as it was then spelled.

Debtors' prison is a concept that is somewhat hard to get our heads around in an age of hefty credit card balances and mortgage defaults. But in early Virginia, debts were taken a bit more seriously. Those who couldn't pay what they owed were locked up until payment was made. The idea was that family members might scrape together the necessary funds, or if a man was holding out on his creditors, he would come up with the money when faced with the ignominious alternative.

Imprisonment for debt was not nearly as commonplace in Maryland or Delaware. In Virginia's portion of Delmarva, debtors' prison was a carry-over from English tradition. In fact, none other than the father of Charles Dickens was thrown into debtors' prison. The family was consequently plagued by hard times and shame, something that Dickens would strive all his days to overcome but that also lent so much social consciousness to his writing. It's also said that Edgar Allan Poe, while a student at the University of

The old debtors' prison in Accomac, Virginia, is now a local museum. *Courtesy Library of Congress.*

Virginia, enlisted in the military to avoid debtors' prison. Virginia governor Henry "Light-Horse Harry" Lee—Revolutionary War hero and father of Robert E. Lee—wasn't so lucky, spending two years imprisoned for debt. If Virginians went so far as to lock up a war hero and former governor, you can see that they took their account books rather seriously.

The prison at Accomac was built in 1783 originally as a home for the man who oversaw the county jail next door. According to the Virginia Landmarks Register and National Register of Historic Places, the prison is the oldest public structure in Accomac County.

To call the building a "prison" is something of a stretch, considering that it measures just eighteen feet by thirty feet. According to historians, practical-minded local politicians who, one might guess, were owed a few dollars here and there had the jailor's former home converted to a debtors' prison. (In the early 1800s, a state law was passed that debtors had to be imprisoned separately from more hardened criminals, such as murderers.)

Best of all, the conversion would be easy on the public coffers. Officials noted "that iron bars to the windows of inch iron and oak Batton doors to be hung outside, is all that is necessary to be done to the said house, to answer the purposes intended, because it is believed that debots have no inducement to break prison, the Law authorizes them with little trouble to discharge themselves whenever they wish so to do."

In other words, pay your debts and you get out of jail.

Odd as it may seem, men held in debtors' prison were sometimes allowed to leave in order to conduct business. Business could even be conducted from the jail itself. In most prisons, those who could afford it would even have their food and drink delivered, since it was better than what was served up at the local jail.

Accomac isn't the only town on Virginia's Eastern Shore with a debtors' prison. Eastville in Northampton County is located about fifteen miles north of Delmarva's southernmost tip, and its "prison" may be even older, possibly dating to 1743. That date does give the Eastville Debtors' Prison some claim to being one of the oldest jails in the nation. (Historians say, however, that it's more likely that the seventeen- by seventeen-foot building was constructed about 1814.)

The debtors' prison in Eastville, Virginia. *Courtesy Eastern Shore of Virginia Public Library.*

The prisons were closed in 1849, when imprisonment for debt was outlawed in Virginia.

That wasn't the end of the buildings, however. The old prison in Accomac was used for many years as a library and now serves as a local history museum. The old prison in Eastville is used to display antique farming tools.

After combing the historical records, I could find no personal accounts or anecdotes about these prisons. That being the case, I suppose that being imprisoned for debt was seen as a shameful matter, something that was best swept under the rug.

These tiny prisons serve as a reminder that on Virginia's Eastern Shore there was a time when getting in over your head financially could put you behind bars. It's likely that locking up debtors was not a very effective method for wringing money out of them; in modern times they are simply issued credit cards with exorbitant interest rates.

Part II

WAR OF 1812

THE TOWN THAT FOOLED THE BRITISH

St. Michaels, Maryland

"You better not be the one who wrote the article in that magazine," the older gent fired off at me, lifting his sunglasses to take aim with an icy glare.

"What article?" I sputtered, taken aback by the note of steely challenge in his voice.

"The one that says the legend isn't true."

Fortunately, I was not the guilty party. I had just written a book about the War of 1812 on Chesapeake Bay and was in town for a book signing, but those pages didn't call into question St. Michaels' best-known legend from the War of 1812. A recent article in a popular magazine had done just that. No wonder my new friend was upset. St. Michaels is a town that has built its popular tourism image around the story of how clever townspeople outwitted the Royal Navy nearly two centuries ago.

The sign as you cross over the Miles River into town says it all: "Welcome to St. Michaels. The Town that Fooled the British."

Here's what happened. During the War of 1812, Royal Navy forces were wreaking havoc on Maryland's Eastern Shore. Early on the morning of August 10, 1813, the British set their sights

on St. Michaels. It was rainy and dark, so that dawn was a long time coming. The local militia mounted a defense with about five hundred troops from Talbot County. These troops set up a battery and fired at the oncoming British.

According to local legend, part of that defense involved hanging lanterns in trees and from the masts of ships tied up at the town dock. When the British bombarded the town by the gloomy light of dawn, they aimed for the lights and overshot the town. Not all the British shots missed, however; one home that was struck survives today as the town's famous "Cannonball House."

Questions arise because in the military record there doesn't seem to be any mention of the ruse undertaken by town residents. The general in charge of the Talbot County militia notes only that "[s]ome of the houses were perforated, but no injury (occurred) to any human being."

St. Michaels isn't the only Delmarva town to be fired upon by the British during the War of 1812. On the other side of the peninsula, the town of Lewes on Delaware Bay has its very own Cannonball House, courtesy of another Royal Navy bombardment.

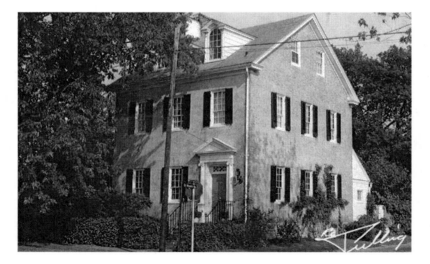

The famous Cannonball House in St. Michaels didn't escape British wrath during the War of 1812, although most of the town did, thanks to a clever ruse. *Courtesy Historical Society of Cecil County.*

Did the people of St. Michaels actually fool the British? Historians do question the truth of the legend, saying that it's unlikely the British attacked in darkness, for starters. But if you really want to challenge the town's favorite story, be forewarned that you might receive the same greeting the Royal Navy got in 1813.

SIR PETER PARKER'S FATEFUL LETTER

Chestertown, Maryland

Captain Sir Peter Parker was a rising star in the Royal Navy. At just twenty-eight years old, he was already captain of his own ship. Dark-haired and handsome, he was a member of the British aristocracy and held the hereditary title of baronet (one "step below" a baron and so addressed as "Sir" rather than "Lord"). Parker's wife, Marianne, was first cousin to Lord Byron, the famous and wealthy

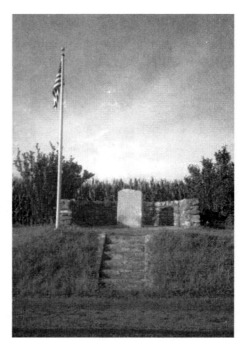

The granite monument marking the Caulk's Field battleground. *Author's photo.*

poet. All in all, Parker was well connected and capable and had what appeared to be a bright career ahead of him.

But all of that would change in a single ill-fated night, foreshadowed in a cryptic letter that Captain Parker wrote to his wife.

It seems clear now that Parker must have felt that he had been sidelined that summer during the War of 1812, sent to patrol and raid Maryland's Eastern Shore. The real action that August was taking place around Washington City, where British forces under Sir Robert Ross and Admiral George Cockburn were planning to capture the United States capital.

Parker's role was to create a diversion to keep Marylanders busy, thus tying up reinforcements that might otherwise have been sent to the defense of Washington. Parker's mission was strategically important, but he knew that the real action was taking place far from Maryland's Eastern Shore.

By his bold actions, Parker may have hoped to snatch some of the glory away from his superiors, or else he simply underestimated the local militia. What is clear is that Parker and his troops got more than they bargained for.

Parker's ship, the frigate HMS *Menelaus*, was anchored off Fairlee Creek in Kent County. The British had been busy raiding farms and plantations, carrying off wine, ham, chickens, salted fish and smoked oysters. The raiders burned whatever they could not take with them, including barns and houses.

The local militia tried to fight back, but by the time the Americans saw smoke rising on the horizon, the British had already returned to their ship. Finally, on the night of August 30, luck favored the Kent County militia. Colonel Philip Reed was camped with his regiment of 174 men, mostly local townspeople and farmers.

When Parker got news that a sizable force of Americans was located not far from shore, he decided that he would make a surprise attack on the militia camp. He would kill or capture as many as he could. With the militia defeated, the way might then be clear for an attack on Chestertown, the county seat and a fairly substantial port town.

Just before leading his troops ashore, Captain Parker closed himself in his cabin and wrote an intimate letter to his wife:

HMS Menelaus
August 30th 1814
My Darling Marianne

I am just going on desperate service and entirely depend upon valor and example for its successful issue. If anything befalls me I have made a sort of will. My country will be good to you and our adored children. God Almighty bless and protect you all. Adieu, most beloved Marianne, adieu!

Peter Parker

P.S. I am in high health and spirits.

Parker landed at night with as many as 170 British troops. The element of surprise was lost when the British encountered pickets and scouts, who fired warning shots. Nevertheless, the British rushed on to attack the American camp.

Colonel Reed, however, was wilier than the British had come to expect from local militia commanders. A veteran of the Revolutionary War and a former United States senator, Reed was a capable leader. He quickly determined where the British would come out of a road through the woods and into a field of tall corn. He hid his men in the corn and placed his artillery on a hill overlooking the road.

The British rushed into the moonlit field, directly into the American ambush. Muskets and grapeshot from the cannons cut down the redcoats as easily as cornstalks.

Parker fell in the first volley, wounded in the leg. He bled to death within minutes. With Parker and fourteen others dead, and twenty-seven wounded, the British retreated. They carried Parker's body five miles back to the waiting launches, harassed all the while by the local American cavalry.

More than one local legend surrounds Parker's defeat and death. One is that he had boasted, "I shall eat breakfast in Chestertown or hell." Another is that in order to preserve the aristocrat's body in the August heat, his men pickled him in a barrel of rum for shipment back to England. No one has ever been able to determine for certain if

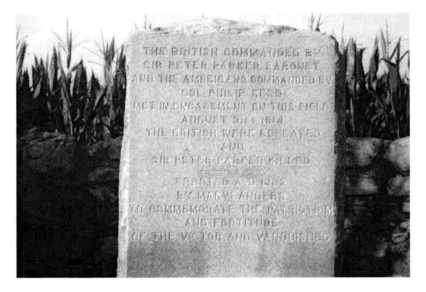

A granite monument erected in 1902 reads: "The British Commanded by Sir Peter Parker Baronet and the Americans commanded by Col. Philip Reed met in engagement on this field August 31st, 1814. The British were defeated and Sir Peter Parker Killed." *Author's photo.*

either story is true, but even now locals love the idea that the man who was planning to burn their beloved town left in a barrel of rum instead.

Did Parker have a battlefield premonition that he would never return home? While it's not an unusual emotion for a soldier to experience, there was no real reason for Parker to expect the local militia to do anything but run. And yet his final letter to his wife has an unmistakable tone of farewell and foreboding.

His passing did not go unnoticed. Captain Sir Peter Parker, killed on a distant battlefield on Delmarva, was finally laid to rest with pomp and circumstance in England. His famous relative, Lord Byron, penned an elegy that includes this stanza:

> *And, gallant Parker! thus enshrined*
> *Thy life, thy fall, thy fame shall be;*
> *And early valour, glowing, find*
> *A model in thy memory.*

Today, a granite monument erected in 1902 marks the Battle of Caulk's Field in Kent County, but it is the story of Peter Parker's final, heartfelt letter that stands as his most lasting monument.

KITTY KNIGHT

Georgetown, Maryland

More than any event in Delmarva history, the War of 1812 brought fear and destruction to the region's waterfront towns and farms. Royal Navy forces raided Maryland, Virginia and Delaware at will, pillaging and burning. Local militia did its best to mount a defense, but these part-time soldiers were no match for the hit-and-run tactics employed by the Royal Navy's combat veterans of the Napoleonic Wars.

Every now and then, though, even the mighty forces of the Royal Navy met their match in the most unlikely of places.

This is just what happened on May 5, 1813, when a substantial force under British admiral Sir George Cockburn sailed up the

This is Kitty Knight's house, very much how it must have looked when she saved it from the British during the War of 1812. *Courtesy Historical Society of Cecil County.*

47

Sassafras River, bent on destruction. Accounts suggest that the British had five hundred men in five thirty-foot assault ships, each armed with small cannons. Their target was Georgetown in Kent County, Maryland, and another village, Fredericktown, on the opposite bank of the river in Cecil County, Maryland.

As he ascended the river, Cockburn sent two captured slaves to warn the Americans not to resist. If no shots were fired, he claimed that he would only burn the ships at anchor and the storehouses, leaving private homes untouched.

His request was ignored, as even Cockburn must have expected. The Americans were not about to give up without a fight. American militia had built a makeshift fort overlooking the river. In and around this earthwork, about four hundred men and some cannons were under the command of Colonel T.W. Veasey, a local plantation owner. Veasey, who would someday become governor of Maryland, ordered his men to open fire. The Americans put up a stiff resistance for nearly thirty minutes. But as the British prepared to storm the little fort, the militia melted into the countryside.

Their blood was up as the British troops fell upon the waterfront villages. Smoke and flames soon filled the May sky. The British burned mechanic shops, granaries, storehouses, twenty-three private homes in the villages, several area farmhouses, taverns, a large schooner at anchor and three smaller ships. A witness to the attack described the scene in a letter that was later published in the *Niles Weekly Register*, "Admiral Cockburn's officers behaved in…inhuman, indecent style."

While the local militia had fled before the British, it would turn out that a young socialite, armed with a broom, would stop them in their tracks.

Kitty Knight was a wealthy young woman celebrated for her beauty. As a pretty young belle, she attended balls in Philadelphia, where she captured the eye of General George Washington, among others. It might seem odd that she was in Georgetown, but this was her home. Two centuries ago, in Kitty Knight's time, it was not so much a sleepy village as a busy port town through which passed some of the more notable men of the day, including Washington and James Madison. But how had she managed to stay here, alone

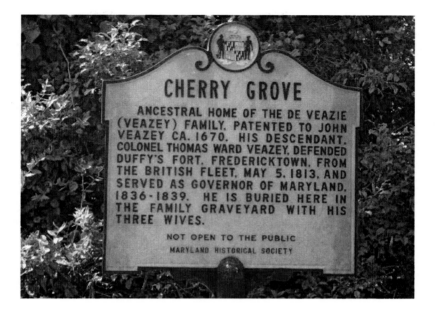

Cherry Grove was the home of Colonel Veazey, who tried unsuccessfully to stop British forces intent on burning Georgetown and Fredericktown during the War of 1812. His defeat didn't seem to matter to Marylanders, who elected him governor in 1836. *Author's photo.*

and single? As we shall see, there may have been a tragic side to Kitty Knight, despite her wealth and beauty.

As the attackers rampaged through the town, a group of British sailors ran toward her substantial brick home, torches in hand. Kitty is said to have stepped out on the front porch and confronted them.

Local legends have grown over the years that describe Kitty waving the stars and stripes in the faces of the British or chasing off Royal marines with a broom. These accounts have prompted comparisons between Kitty Knight and Barbara Fritchie, the patriotic Maryland heroine of John Greenleaf Whittier's famous Civil War poem.

Her own account is more matter-of-fact than poetic. "The British, after landing, commenced to burn all the lower part of the town, which was largely of frame," she wrote many years after the attack.

There were, however, two brick buildings on top of the hill—they are there today—which had not as yet been fired. In one of them was an old lady sick and almost destitute, and to this building the Admiral and his sailors and marines proceeded at a rapid gait. I followed them but before I got to the top of the hill, they had set fire to the house in which the old lady lay. I immediately called the attention of the Admiral to the fact that they were about to burn up a human being and that a woman, and I pleaded with him to make his men put the fire out. This I finally succeeded in doing, when they immediately went next door, not forty feet distant and fired the second of the brick houses. I told the commanding officer that as the wind was blowing toward the other house the old lady would be burned up anyhow, when, apparently affected by my appeal, he called his men off but left the fire burning, saying "Come on, boys!" As they went out of the door, one of them struck his boarding-axe through a panel of the door.

When the British finally rowed away, the destruction of the town was complete. As many as three hundred homes and storehouses were burned. Kitty Knight's house was one of the few structures still standing. Kitty Knight became a local hero for standing up to the British just when one was badly needed.

At the same time, one can imagine that the simple fact that she had managed to save her own house when so many others were destroyed might have created some hard feelings. This lingering bitterness may even have engendered rumors that Kitty Knight offered the British something more than sharp words. Even now, there are persistent stories that Miss Kitty was a kind of madam and that her house had been spared because some of the sailors had fond memories of the rooms upstairs.

Rumors aside, did Kitty Knight have a dark side? If so, some hint may lie in the fact that she never married—a rarity for an eligible early nineteenth-century woman.

In his book *Lost Towns of Tidewater Maryland*, author Donald Shomette relates how the same anger that drove Kitty Knight to challenge the British was unleashed on defenseless victims as well. It seems that she was madly in love with a rich young man from the

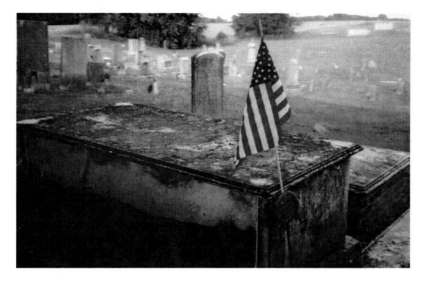

Kitty Knight's substantial tomb is located at St. Francis Xavier "Old Bohemia" Church near Warwick, Maryland. Each Memorial Day, her grave is decorated with an American flag in honor of her bravery during the War of 1812. *Author's photo.*

area named Perry Spencer and that they were to be married. One day, Spencer came upon a scene involving his fiancée that disturbed him greatly. Unseen, he watched as Kitty Knight fell into a rage and severely beat a slave boy who she thought had mistreated her horse. Appalled, the young man wrote her a note ending their engagement and never saw her again.

What became of Kitty Knight? While her brave defiance of Cockburn made her a local legend, she lived out her life in Georgetown, dying at age seventy-nine in 1855. You can visit her impressive tomb at the historic St. Francis Xavier "Old Bohemia" Church in nearby Warwick. Better yet, spend the night or enjoy a meal at the Kitty Knight House, an inn and restaurant that occupies the home she saved from the British two hundred years ago.

THE BATTLE FOUGHT AFTER WAR'S END

Taylor's Island, Maryland

When American and British forces clashed at Parson's Creek near Cambridge, they didn't realize that the War of 1812 had been over for several weeks.

Peace commissioners had signed the Treaty of Ghent on Christmas Eve 1814. The British, weary of their long war in Europe against Napoleon, were eager to end hostilities. The young United States had found that it wasn't so easy to achieve a clear victory. Both nations were glad to put the conflict aside. Unfortunately, it would take weeks for word of the treaty to reach North America, considering that news only traveled as swiftly as the swiftest ship.

The news came too late to prevent the Battle of New Orleans on January 15. Hundreds of British were killed or wounded in a battle that cost fewer than sixty American lives. This victory would eventually propel Andrew Jackson to the White House.

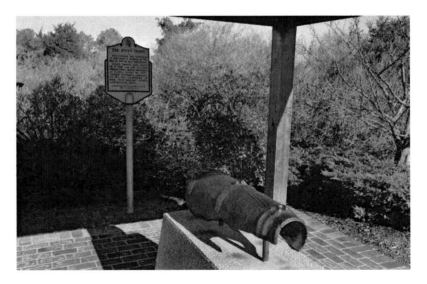

The "Becky Phipps" cannon, captured during the last battle of the War of 1812 on Chesapeake Bay, can still be seen in Dorchester County. *Photo by William Johns.*

For the British and Americans still fighting on Delmarva, news of the peace would also come too late to stop a battle—although one on a much smaller scale than at New Orleans.

The winter had been a hard one on Chesapeake Bay, with ice clogging the creeks and rivers. On February 7, 1815, that ice proved to be the undoing of a British vessel and its young commander.

Lieutenant Matthew Phipps was probably foraging for supplies or else on a scouting expedition to keep an eye on American activities. The two vessels under his command were "tenders," or ship's launches, from the HMS *Dauntless*. But these were no mere

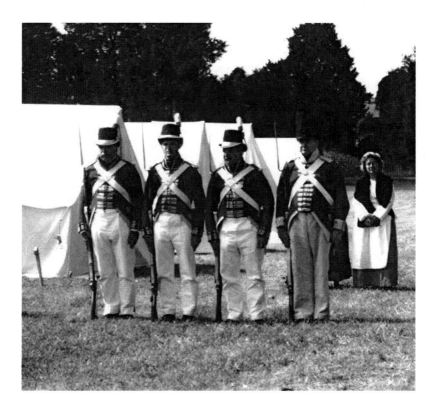

Reenactors portray Royal marines during a War of 1812 living history event at Jefferson Patterson Park and Museum in Calvert County, Maryland. The marines were far better equipped and trained than the local militia trying to defend their farms and towns from British raiders. *Author's photo.*

rowboats. Phipps's launch was equipped with a twelve-pound cannon and a smaller swivel gun. Accompanying Lieutenant Phipps were a midshipman, twelve sailors, three Royal marines and an African American cook named Becky.

At some point, this British expedition ran into trouble when it became stranded in ice that had been built up by the wind and tide to form the "Ice Mound" that gave the battle its name. Watching from shore, Americans saw that the British were ensnared. Quickly, they assembled the Forty-eighth Regiment of Maryland militia, commanded by Lieutenant Colonel John Jones.

Trapped in the ice, the British must have made an easy target for the Americans firing from shore. The British fought back, but Lieutenant Phipps must have realized the futility of his position, exposed in open boats while the Americans picked them off. He surrendered to save the lives of his men.

It must have felt like a tremendous victory to beleaguered American forces. The captured British were marched victoriously to Easton, with the cannon dragged along as a trophy of war. Seven days later, word finally arrived that the War of 1812 was over.

The British were released, but the Americans kept the cannon. It was nicknamed "Becky" for the cook and "Phipps" for the hapless Royal Navy lieutenant who had been captured. The "Becky Phipps" cannon was fired on special occasions over the years, until it finally exploded when too much powder was loaded at the inauguration of Woodrow Wilson (or possibly Grover Cleveland). A local family retrieved the shattered pieces and reconstructed the cannon, and it can be seen today under a pavilion at Taylor's Bridge. These days, the cannon isn't fired anymore, but it serves as a reminder of that final War of 1812 battle on Chesapeake Bay.

DIVIDED DELMARVA: THE CIVIL WAR

Thomas McCreary: Notorious Slave Catcher and Kidnapper

Elkton, Maryland

At the same time that the famous Underground Railroad was working to spirit slaves to freedom, some individuals worked just as hard to return Delmarva's African Americans to enslavement.

One such slave catcher was Thomas McCreary. Today, there is a growing interest in this relatively forgotten Marylander who used Cecil County as a base for kidnapping free blacks and selling them back into slavery. One such foray into Pennsylvania ended in a murder that was covered up by Maryland's highest officials and that touched off a national controversy that almost got the Civil War started a few years ahead of schedule.

Few personal details are known about McCreary. He was just one of many rough, nefarious characters—the notorious slave catcher and killer Patty Cannon comes to mind—who made a living from operating a kind of reverse Underground Railroad.

McCreary appears to have lived on the margins of respectable society. At various times, he worked as mail carrier and tavern keeper. But at some point, McCreary's fortunes appear to have taken a turn for the worse, and he became involved in the shady enterprise of slave catching.

According to Milt Diggins, a local historian who has dedicated several years to following McCreary's nineteenth-century paper trail, it's possible that McCreary—described by one victim as "an old sot"—spiraled downward into alcoholism.

It could be that some personal tragedy may have hardened his heart. In any case, McCreary appears to have embraced the easy money afforded by enactment of the Fugitive Slave Act of 1850. This national law allowed pursuers to cross into states where slavery was outlawed to seize their human property. Then again, McCreary often ignored the laws and procedures in place as well.

McCreary lived close to Pennsylvania, where slavery had been outlawed. (Slavery remained an institution in Maryland and Delaware.) The United States had long since banned the importation of new slaves, but there was a tremendous demand for labor in the Deep South. The slave markets of Baltimore did booming business as Delmarva's slaveholders "downsized" in the years leading up the Civil War—not that slave traders there were too particular about where their goods came from.

Over the years, McCreary made several forays into Pennsylvania to snatch free blacks. He spirited them back into Maryland, where he caught the train for Baltimore. The sale at the slave market made him a tidy profit.

In the winter of 1851, however, McCreary got more than he bargained for when he and an accomplice slipped into Pennsylvania to kidnap sixteen-year-old Rachel Parker from a farmstead in West Nottingham. Parker was not a runaway slave; in fact, she had been born in Pennsylvania and worked at the Miller house for about six years. Just a few weeks earlier, McCreary had kidnapped the girl's younger sister, Elizabeth, and sold her at Baltimore. (Due to the attention her sister's case received, Elizabeth would resurface months later in New Orleans, where she had been enslaved, and eventually be recovered from slavery.)

McCreary ran into trouble from the outset. When he burst through the door and grabbed Rachel, Mrs. Miller and her children began screaming for help. That brought her husband running. Joseph Miller grabbed Rachel's arm and tried to pull her away. McCreary threatened him with a knife and made his getaway with the girl.

Joseph Miller, however, did not give up. Angry and outraged, he chased McCreary's wagon for some distance before the slave catcher disappeared toward Maryland. By that evening, McCreary had boarded a train at Perryville in Cecil County and taken the girl to be sold at Baltimore.

Tensions were already high between Maryland and Pennsylvania. McCreary and others like him had been busy for years, making raids to snatch runaways and free blacks back into slavery. Just three weeks earlier, an event known as the Christiana Riot had taken place when a Maryland slave owner and a band of friends had entered Pennsylvania to reclaim a runaway slave. The slaves and several abolitionists fought back, killing the man and severely wounding some others. Marylanders felt that their rights were being abused and had promised to hang "the first Abolitionist that they should catch in Maryland."

Pennsylvanians felt that they were at the mercy of lawless brigands and raiders. Demands were made for the governor to protect their rights and restore public safety. At issue was not only the sovereignty of individual states but also the conflicting values and economic models of North and South.

In other words, the political powder keg was already primed and waiting, with Thomas McCreary as the fuse.

Miller turned out to be the match. He was very determined to get Rachel back rather than see her thrown into slavery. She had, after all, been part of the Miller family for years. With a group of abolitionist-minded friends, he journeyed to Baltimore and protested Rachel's kidnapping. She would not be sold but was instead transferred to the city jail until the truth of the matter could be decided. McCreary was arrested on charges of kidnapping.

Satisfied that Rachel would not disappear into enslavement in the Deep South and that the wheels of justice had been set in motion against McCreary, Miller and his friends boarded a train back to Pennsylvania. At least some of them must have sensed danger in the air, however, because they tried to talk Miller out of stepping out onto the platform to smoke a cigar when the train made a stop at Stemmer's Run about nine miles outside Baltimore.

Miller never returned. Alarmed, his friends searched for him but only found the smoking remains of his cigar. The Pennsylvania abolitionist had disappeared.

Perhaps fearing for their own lives, the men returned home. That night, they organized a band of thirty armed men to return to Baltimore and search for Miller. But as they prepared to leave the next morning, news came that Miller's body had been found hanging from a tree near the train tracks. A sham inquiry later made the "official" determination that Miller had committed suicide, despite the fact that his hands were bound and his body showed signs of having been tortured. Maryland officials ordered a hasty burial, but Miller's friends would disinter his body under cover of darkness and carry it home.

The brazen kidnapping, mysterious death and consequent trial soon gained national attention. The case brought North-South tensions to a head, and Thomas McCreary became a symbol for good or evil, depending on one's point of view.

Pennsylvania demanded that McCreary be returned to that state for trial, but none other than Maryland's governor would not allow it. The two states had reached the equivalent of a Mexican standoff.

Several prominent Pennsylvanians, including the Keystone State's attorney general, were dispatched to represent that state's rights and protect the rights of Pennsylvania citizens. McCreary—a man who was practically destitute—found himself being defended by Baltimore's leading attorneys, including a former governor. Poor Rachel Parker was used as a pawn, with an agreement reached that she would be released from jail in return for Pennsylvania dropping its efforts to put McCreary on trial there.

To be sure, McCreary's actions launched a war of words between proslavery Marylanders and Pennsylvania abolitionists. Emotions ran high and brought on violence, such as Miller's death, but eventually an uneasy compromise was reached. Just ten years later, however, these same unresolved issues would evolve into the bloodiness of the Civil War.

McCreary was a kidnapper and brute and possibly even a murderer. How could someone so reprehensible not only avoid

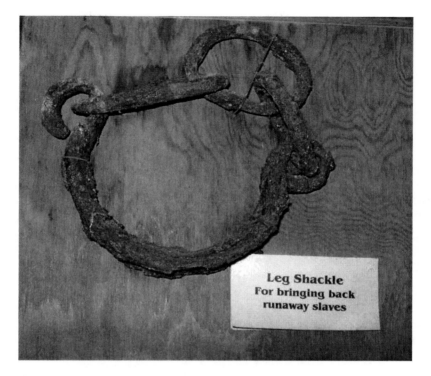

This shackle was found at Mount Harmon Plantation on the Sassafras River in Cecil County, Maryland. *Author's photo.*

prison but actually be rewarded for his crimes with some form of social acceptance, including a job?

Diggins believes that as unsavory as McCreary must have been, he was seen as a useful tool for more powerful men of his day. When slaves escaped, he caught them. He generated a certain amount of fear among the enslaved and free black population. McCreary's actions had given slave owners an opportunity to defend and extend their legal high ground.

Like many notorious criminals showcased in today's headlines, McCreary faded away after his time in the spotlight. But someone must have appreciated his talents. McCreary was eventually made the sexton at the Episcopal church in Elkton and also held the office of bailiff in Cecil County. It just goes to show that in 1850s

Delmarva being a slave catcher had its rewards if one had friends in high places.

HARRIET TUBMAN AND THE UNDERGROUND RAILROAD

Dorchester County

If there was any time when an unlikely angel came to live among mere mortals, it was probably the day Harriet Tubman was born. Although even she didn't know the year of her birth—historians say it was about 1820—by the time of her death ninety years later this former slave was one of the great heroes of her age. While she was certainly an individual of uncommon tenacity, Tubman was driven in part by strange visions and dreams that convinced her that she was touched in some way by God.

A statue of Harriet Tubman by James K. Hill was dedicated in 2009 at Salisbury University. Tubman may have led hundreds to freedom on the Underground Railroad at great risk to her own life. *Photo by Patrick Morris.*

Yet it was hardly divine inspiration that brought on these dreams and visions. Instead, it was the spontaneous brutality of a slave overseer.

Tubman was born into a life of suffering and hard labor that is difficult to imagine or reconcile. Her brothers and sisters were sold off, never to be seen again. As a girl of just five or six years old, her first job was to watch a baby. Whenever the baby woke up and cried, little Harriet was beaten so hard that she was left with scars.

At one point, the girl escaped and hid on the farm, living off scraps left for the pigs. When she finally returned, she was beaten even more severely.

From these earliest days, there was a fire of resistance and anger in her. No matter how much she was beaten or mistreated, there was a part of her that seemed beyond the reach of the whip or the lash. It could be that her owners and bosses over the years saw this quality in their slave, which made them mistreat her even more out of sheer frustration.

One act of defiance as a teenager almost got her killed. Tubman had been hired out to work on a nearby farm and was sent to pick up supplies at a local store. It so happened that a slave missing from another plantation was there. An overseer came in after him. Tubman—who as an adult would be five feet tall and never weigh more than eighty pounds—stepped between them to give the other slave time to run out the back. At that moment, the angry overseer hurled a two-pound weight from the store's counter. It struck Tubman in the head, and the force of it "broke my skull," as she later described it.

For days that followed, Tubman drifted between life and death. The slave owners basically let her lie there unattended like some wild animal left to heal itself—or die. Tubman lived and was immediately sent to work in the fields, still dizzy and bloody.

For the rest of her long life, Tubman would be afflicted with narcolepsy—sleeping fits that came on with no warning and from which no one could wake her. Tubman said that during her spells she had strange, waking dreams. Tubman could not read or write, but she loved Bible stories, especially the Old Testament accounts of righteousness and deliverance. She interpreted her visions as coming from God and looked to them for guidance.

In 1849, Tubman ran away from her brutal life in Dorchester County and escaped to Preston in Caroline County and then through Middletown, Delaware, and ultimately to Philadelphia. The notorious slave catcher Patty Cannon was dead by then, but there were others just as eager to capture runaways and collect the reward.

Once in Philadelphia, Tubman worked various odd jobs to support herself. But she soon returned to Maryland to bring family members to freedom. Again and again, Tubman made trips to the slaveholding areas of Delmarva to bring African Americans to freedom. Historians debate just how many people she conducted on the Underground Railroad. There is documentation that she carried seventy to freedom, but it is entirely possible that she liberated hundreds from enslavement. It was no easy journey, undertaken in harsh conditions at night and in all sorts of weather. Sometimes, slaves wanted to give up and go back, but Tubman threatened them with a pistol.

Her exploits soon earned her a great deal of enmity, and her face went up on wanted posters up and down Delmarva. If she had been caught, Tubman would surely have faced a horrible death, but she was a driven, almost fanatical individual.

Ironically, Tubman and her family should not have been enslaved at all. Later in life, Tubman learned that her mother and father—and through them, Tubman herself—had been manumitted or freed in a provision of a previous owner's will. However, that clause was ignored by the dead man's family members, who weren't so eager to give up their valuable human property.

Tubman served as a guide and nurse during the Civil War and worked her whole life in the service of others. She moved to Auburn, New York, and supported herself by growing vegetables and selling them door to door. The greatest conductor of the Underground Railroad lived most of her life in abject poverty. Although she was widely known in her lifetime, it would only be later in the twentieth century that her contributions to bringing an end to slavery would be fully understood.

Upon her death in 1913, admirers had a headstone made for her that reads:

Born a slave in Maryland about 1821
Died in Auburn, N.Y., March 10, 1913
Called the "Moses" of her people,
During the Civil War, with rare
Courage, she led over three hundred
Negroes up from slavery to freedom
And rendered invaluable service
As nurse and spy.
With implicit trust in God
She braved every danger and
Overcame every obstacle, Withal
She possessed extraordinary
Foresight and judgement so that
She truthfully said—
"On my Underground Railroad
I never ran my train off the track
And I never lost a passenger."

Was Harriet Tubman truly touched by God? Experts today say she likely suffered from temporal lobe epilepsy brought on by her severe head injury. However, it was enough if Tubman herself believed that she was guided by God's hand, and perhaps that belief lent strength to her already divine spirit.

CLARA GUNBY HUFFINGTON: SPY FOR THE CONFEDERACY

Salisbury, Maryland

It's no secret that Delmarva was deeply divided during the Civil War era. Depending on their loyalties toward the North or South, neighbors sometimes found themselves pitted against neighbors or brothers against brothers.

No matter what their allegiance, the fact remained for Delmarva residents that Maryland and Delaware were part of the Union. Federal troops were dispatched to keep it so. Detachments of Union troops were

garrisoned in areas with pro-Confederate sentiments so that Southern sympathizers expressed any anti-Union opinions at their peril.

In some towns, loyalties were formally put to the test using methods that might have made Senator Joseph McCarthy proud a century later. In Pocomoke, Union troops were said to have strung a giant United States flag across Main Street. Southern sympathizers allegedly refused to pass under the flag, detouring down the alleys and side streets instead. Pocomoke must have had some unusually strong anti-Union feelings, because housewives were said to angrily sweep the sidewalks clean after blue-coated troops passed by.

Tests of loyalty to the Union weren't limited to Pocomoke but also took place in Salisbury, where troops likewise displayed a large United States flag and required citizens to walk beneath it. For at least one pro-Southern citizen who refused to honor the flag, there would be dire consequences.

Clara Gunby was born in Forktown (now Fruitland) to a wealthy family. She was educated in Salisbury and attended college in Baltimore. Interestingly, she would become a talented portrait and landscape artist. Diary entries from her school days indicate that Clara was a playful and headstrong teenager—and not particularly good at spelling—used to getting her way and doing as she pleased: "I have made so many pleasant acquaintances. They all say I'm bad, I don't like that, O we have so much fun!"

The Edward H. Nabb Research Center for Delmarva History and Culture at Salisbury University has a collection of Clara's paintings and has published her extensive Civil War–era journals, which is how we know the details of her story today.

She was just twenty-two years old when war broke out. The Gunby family must have had strong feelings for the South, because her brothers enlisted in the Confederate military. If she had been a man, it's likely that Clara would have done the same. However, she would soon serve the cause in other ways.

The war forced Salisbury residents to choose sides. If Clara thought that she could turn up her nose at the Union, she was sadly mistaken. The details of the incident are not recorded, but when Clara refused to walk under a Union flag she was arrested by Union troops, sent to Baltimore for trial and convicted of treason. The

carefree young woman from Salisbury found herself imprisoned at Fort Monroe, Virginia.

It seems like an unusually harsh sentence for the crime, but it shows how seriously Union troops took any show of defiance by Southern sympathizers. Little did the authorities know that instead of reforming this Southern belle and teaching her a lesson, their actions would create a spy for the Confederacy, whose secret missions for the South would take her all the way to the Confederate White House in Richmond.

Clara's career as a spy began at Fort Monroe, where she met other loyal women imprisoned by the Union. Some, like Clara, had been imprisoned for their outspoken opinions or actions. Others had been more actively involved in opposing the Union. One such woman was Mrs. Amy Francis Cormick, a spy who passed information to the Confederate high command even after being interred at Fort Monroe. It seems that Clara and Mrs. Cormick became acquaintances while held captive.

After several months of captivity, Clara was "paroled" as part of a prisoner exchange program. But before her release, Mrs. Cormick held a furtive meeting with Clara, asking her to deliver a secret message directly to the president of the Confederacy, Jefferson C. Davis. Clara agreed, committed the message to memory and then set out for Richmond.

The world that greeted Clara now was quite different from what she remembered. It was the summer of 1864, and the war was not going well for the Confederate States of America. She described crossing the James River under a flag of truce and going over to the Confederate pickets: "I gave one of them lunch, he was glad of the change. He told me he lived on bread & a scanty allowance of meat for months...As far as the eye could reach we could discern smoking ruins, away down the river was seen dark columns of smoke ascending from smoldering ruins of a burning mansion, whose occupants were driven fourth alone & penniless."

Clara must have realized that the stakes for her secret message were higher than when she first agreed to carry it. Once in Richmond, she penned a note that she delivered to the Confederate White House:

Mr. President Davis:
While imprisoned at Fortress Monroe, a message was given to me
with a promise of immediate delivery to you in person. Hoping
you will grant me an interview this evening.
I am very respectfully
Clara Gunby

That evening, Davis met with Clara and heard her message. The information Clara had been given was about a dangerous double agent in Charleston. The Confederate president heard what she had to say and thanked Clara for all that she had done and suffered.

She described the meeting with President Davis in her journal entry of July 13, 1864:

Union officers and their wives pose for a photograph at Fort Monroe. During the Civil War, Southern sympathizers such as Clara Gunby Huffington found conditions less welcoming at the prison. *Courtesy Library of Congress.*

He came several steps down the porch with me. He looked so venerable, so good & kind that I should have loved & admired him if he had been a beggar. He looks as if he was in delicate health. He is very thin with long white hair. He looks prematurely old, there are deep traces of care discernable, yet the pure chaste & unblemished smile that so often lightens his countenance, convinces us that the look of pain & care is for others woes, for a suffering nation.

After the war, Clara returned to Salisbury, where she married William Huffington. Like many Delmarva residents, she did not dwell on the war or the lost cause but gladly reunited with her old friends and neighbors. She died on October 2, 1890.

It can't be said that her urgent message for President Jefferson C. Davis helped sway the course of the war or even delay the inevitable for the Confederacy. It's not even known whether or not the Union spy was arrested as a result of the information she provided. But thanks to Clara's journals and also her paintings, we can "spy" a bit of the Confederate past in Wicomico County and beyond.

LINCOLN'S "MY DEAR LADY"

Pocomoke City, Maryland

President Bill Clinton had James Carville. George W. Bush had Karl Rove. Known as "spin doctors" in today's parlance, these wizards of propaganda and policy serve to further their president's goals. The same forces were at work in the Civil War White House of Abraham Lincoln; incredible for the time, however, one of his key "spin doctors" and advisors was a woman.

Anna Ella Carroll was born into a wealthy and influential family in 1815 at the stately Kingston Hall plantation near Pocomoke City. Anna, the eldest of seven children, showed from the earliest age a special ability with language and a keen interest in history, law and politics. It's said that when she was just a little girl, her father spent hours reading aloud to her from the works of Shakespeare and Sir

Abraham Lincoln's cabinet during the first reading of the Emancipation Proclamation on July 22, 1862. Some say that the empty chair in the painting by Francis Bicknell Carpenter is actually a reference to Anna Ella Carroll, an unofficial member of his cabinet. *Courtesy Library of Congress.*

Walter Scott and gradually moving on to Alison, Kant, Coke and Blackstone. As a teenager, Anna even served as an informal aide to her father, Thomas King Carroll, Maryland governor from 1830 to 1831.

Anna moved in the very highest social circles of the day, but she did not choose the usual path of a good marriage and children. She was far more interested in politics. Yet it was only relatively later in life that she became truly active in the career that would make her famous.

Probably out of financial necessity due to her family's failing fortune, Anna operated a school for young ladies at Kingston Hall until her mid-thirties. But as national politics grew heated in the years leading up to the Civil War, Anna was unable to watch from the sidelines. She not only wrote about the issues of the day but also became a political organizer who could "scheme, connive, and maneuver as well as any man."

She became deeply involved in the presidential campaigns of Zachary Taylor and especially Millard Fillmore's 1856 White

House bid. She wrote many pamphlets and campaigned through several states on his behalf. In 1857, she was the chief publicist for the campaign of Maryland governor Thomas H. Hicks, who won with her help. Her pamphlets, articles and books on politics began to attract national attention, and she wrote for many of the most popular publications of the day, including the *New York Evening Express* and the *National Intelligencer*.

However, it was the Civil War that would really bring Anna into her own, thanks to the election of President Abraham Lincoln in 1860. At first, Anna was skeptical that Lincoln possessed the leadership skills necessary for the position. However, she was strongly pro-Union and believed that slavery was wrong. Soon after Lincoln's election, she freed her family's remaining slaves as a gesture of support of the new president, although it would prove to be a tremendous financial loss for the Carroll family.

What really brought Anna to Lincoln's attention, however, was a political pamphlet she authored in 1861 in response to Senator John C. Breckinridge of Kentucky. Senator Breckinridge had publicly accused the president of violating the Constitution by his actions calling out state militias, imposing martial law and blockading Southern ports. In her pamphlet *Reply to Breckinridge*, Anna made a well-reasoned legal argument otherwise, showing deep insight into Constitutional law. This pamphlet was even credited with helping to convince many influential Marylanders that the state should not secede. Some sources say she distributed fifty thousand copies at her own expense.

It was at this time, as the nation slipped into Civil War, that Anna purportedly became an unofficial member of Lincoln's wartime cabinet. It is said that he met and corresponded with her frequently, addressing Anna as "My Dear Lady."

Anna's tireless efforts in support of the Union and Lincoln's policies were only just beginning. Her best-known contribution was the Tennessee Plan for invasion of the South, later implemented by General Ulysses S. Grant. On a fact-finding trip, Anna met with everyone from spies to riverboat captains before finally coming up with this strategic military plan. Of course, as a woman, her name was never attached to the plan.

Lincoln's assassination was not only a personal loss for Anna but also one that would throw a shadow over the rest of her days. The simple reason is that Anna never really received public credit for her contributions and her unofficial role as Lincoln's advisor. Later in life, and through the intervention of several congressmen, she would receive a modest federal pension. By this time, the former governor's daughter was basically destitute.

Anna Ella Carroll's true role remains a mystery, however, because there are no documents supporting her claim. No records exist of any meetings between Lincoln and his supposed Maryland strategist. A trunk filled with correspondence between Lincoln and Anna was lost—if it ever really existed.

The lack of proof, however, didn't keep Anna from being a feminist hero and role model for women of the late 1800s and early 1900s. Her life and actions as "the woman who saved the Union" became the subject of popular novels and plays of the era. She was also an inspiration to the suffragist movement seeking the right to vote for women.

It's interesting that, in the famous painting of Lincoln's cabinet by Francis Bicknell Carpenter, there is an empty chair. Some have claimed that the chair represents Anna Ella Carroll's place in the cabinet.

Anna spent her last years in Washington City, growing old and sick and living in relative poverty. She died in 1894 and is buried beside her father in Church Creek, Maryland.

One can only imagine how enormously frustrating it must have been for someone like Anna not only to be denied recognition but also to have her motives and integrity questioned by the very men her contributions had been hidden from in order to save their egos. The one man who could have unequivocally proved her claims had long since joined the ages.

CAVEMAN OF THE CIVIL WAR

Salisbury, Maryland

During the Civil War, it wasn't uncommon to be drafted against one's will and forced to put on a blue uniform. One Delmarva man

hated the Yankees so much that, to avoid this fate, he spent several years living in underground hideouts.

The ordeal of John Long, "Caveman of the Civil War," is certainly one of the stranger tales from the Civil War era on Delmarva. His story was described at length in the *Salisbury Wicomico News* on May 27, 1920.

It is, unfortunately, a secondhand story, recounted from the childhood memories of the newspaper columnist. The newspaper article, and Long's experiences, have been summarized by the Edward H. Nabb Research Center for Delmarva History and Culture at Salisbury University.

"Having made up his mind that he would not obey the call of his country to duty, his chief thought was to find some place where he could hide until the 'unpleasantness,' as he termed it, 'had blown over,'" the columnist wrote.

Long's solution was to build "two or three" underground caves. Like most of Delmarva, the region around Salisbury is a flat and sandy place in which caves do not naturally occur. It's likely that Long built his shelters in stream banks and also along the edge of a place called "Polk's Pond."

These caves were more than crude shelters. Long made them big enough to stand up in, with sides and ceilings finished with boards. He built bunks for sleeping but probably had no stove or hearth, which might give away his hiding place. The entrance was more than likely disguised somehow to avoid discovery.

Long was able to keep a sharp eye out thanks to "portholes" that he built to give himself ventilation and as a means to keep watch. The columnist wrote, "Hundreds of times, he said, the (Yankee) soldiers were within a few feet of his hiding place, but by good luck he escaped."

It seems that the Caveman wasn't just a draft dodger and Southern sympathizer but rather had somehow gotten himself into trouble with the local Federal authorities. A reward was offered for his arrest, and troops combed the countryside looking for him.

Friends apparently kept Long supplied with food, bringing him supplies under cover of darkness. The Caveman, however, wasn't content to spend all of his time hiding out. On several occasions, he

donned a disguise—sometimes dressing as a "Negro woman"—and ventured into town. Long was described as being a big man who weighed 240 pounds, so the sight of him in a dress must have been interesting, to say the least.

One of his favorite haunts was a saloon run by "Old Man Hawkins" that once stood on East Camden Street. As the columnist described it, "Here the friends of the north and of the south often met and many a wordy conflict finally terminated in a 'knock down and drag out' fight."

It's a good bet that John Barleycorn played a role when the Caveman got himself into more trouble than he bargained for one night at the saloon. He got in a fight with several Yankee soldiers. He knocked a few of them down and then punched an officer so hard that he knocked the man out cold. "After a great deal of work on the soldier he was finally revived averring that he had been struck many a time but never so hard as that Negro woman struck him." Somehow, the Caveman must have made it safely back to his hideout.

Was there really a John Long, and did this actually happen to him? When one takes a harder look at his story, parts of it appear to be nothing more than a tall tale, perhaps embellished by the columnist or by the Caveman himself. After all, it seems to stretch the imagination that a young white man, powerfully built at that, could get away with disguising himself as an African American woman—one who hung out in saloons, no less. And would the Caveman really have stuck around to hear the Yankee officer compliment him on that knockout punch? If he felt so strongly about the South, he could have slipped into Virginia to join the Confederacy, like so many other young men from Delmarva. But perhaps John Long was a gentle man and something of a loner, happy to mix things up in a relatively harmless barroom brawl but not eager to join the killing fields of the war.

Later census records do show a John Long in the Salisbury area. There's no mention of him living in a cave, of course, but by then the "unpleasantness" of the 1860s was long since over, and the Caveman of the Civil War had become a local legend.

Part IV

DISASTERS, SHIPWRECKS AND MAYHEM

THE GREAT GALE OF 1878 AND THE SINKING OF THE *EXPRESS*

For most of us, the Chesapeake Bay provides a calm respite, a blue-tinged retreat from the week's labors, a watery view to gaze upon while cracking crabs or a place to dip our toes into gently lapping waves the temperature of a bathtub. It is not a place we associate with storms and shipwrecks. But given the right (or is that "wrong") season and weather, even the calm Chesapeake can be churned into a tempest that rivals the fiercest Pacific typhoon.

Delmarva has been lashed by some vicious storms in the previous four hundred years, but the deadliest of all Delmarva's storms was, by far, the Great Gale of 1878. By the time the storm's fury had abated, crops across the peninsula would be ruined, homes and barns destroyed, telegraph lines knocked out and multiple ships foundered. While many lives were lost on the Chesapeake and the Delaware that autumn day, the worst loss of life would take place during the sinking of the steamship *Express*, when sixteen passengers and crew went to their watery graves.

The storm swept up from Cuba with little warning. Weather experts say that the term "gale" is something of a misnomer because the storm was actually a Category 2 hurricane by today's measure. The storm followed a path similar to that taken in 1954

by Hurricane Hazel, another furious storm that a few Delmarva old-timers may recall. At the height of the 1878 storm, sustained maximum winds reached forty-five miles per hour in downtown Baltimore. Rooftops and church steeples blew away. Smith Island was completely underwater for the first time in memory. Out on Chesapeake Bay, one unlucky vessel would experience the full fury of the storm.

For the crew and passengers of the steamship *Express*, the storm would be a test of wills and courage that several would not survive. But on the afternoon of Tuesday, October 22, the impending storm was just a nuisance for the passengers intent on getting to their destinations. In those days, travel by water was the fastest and easiest form of transportation, and as part of the Potomac Transportation Line, the steamer made regular trips from Baltimore to Washington, D.C., stopping at points along the way.

Captain James T. Barker had heard the forecasts for rough weather and may have been uneasy about the storm. However, he was under orders to keep his schedule, and no one knew the extent of the storm that was churning up the Atlantic coast toward Delmarva.

So, about 4:00 p.m., once the twenty-one crew members and nine passengers had boarded in Baltimore and the cargo had been loaded, he headed the *Express* out of the harbor and into Chesapeake Bay. The trip and the weather were uneventful at first, but the wind began to pick up sometime after midnight. By two o'clock in the morning, it was blowing a gale. And then, all hell began to break loose.

The seas reached mountainous heights as the wind screamed around the ship. Men who had sailed the Chesapeake their whole lives had never seen the waters so wild.

Poor Captain Barker had few options. As Donald G. Shomette recounts in his book, *Shipwrecks on the Chesapeake*, the *Express* was caught between a rock and a hard place as it made its way into the storm because there were no harbors of refuge.

As waves taller than the ship pounded its decks, the ship's hold began to fill with water. The engines flooded, and *Express* was left helpless. Unable to keep turned into the wind with its bow riding the

huge oncoming waves, it was only a matter of time before *Express* turned sideways and rolled. The desperate crew and passengers prepared for the worst by strapping on life preservers or stripping down to give themselves a better chance of swimming. According to Shomette, Ship's Purser I.F. Stone would later recall that the thirty souls on board faced death rather calmly:

> *These preparations were silently made for the fight for life which all saw was inevitable. An audibly uttered prayer here and there, a moan of suppressed emotion from one or another of the passengers in the saloon were all the outward evidences given of the intense feeling which possessed the breasts of all on board.*

Then, about 5:00 a.m., two huge waves struck the ship in rapid succession, and it was all over for *Express*. Passengers and crew were thrown into the raging water. Some clung to makeshift rafts they had managed to lash together, some grasped at boards from the wreckage and one poor woman was last seen floating away on a mattress. Two women were helped into a lifeboat by the crew, who watched in horror as a wave swamped the boat and took the two down with it. Howling wind and rain were compounded by the fact that the survivors struggled in almost total darkness. It was a terrifying fight for survival.

Shomette's account describes how, at first light, some survivors found themselves drifting alone, surrounded by the wreckage. The storm began to abate later in the morning. One man, Quartermaster James Douglas, thought that salvation had arrived in the form of a local schooner that braved the huge waves. Though they had seen him, the crew ignored Douglas and instead picked up barrels of oil and other cargo that could be resold. They apparently wanted no witnesses to their illegal salvage operation. Shomette's account describes how Douglas drifted for twenty miles before another ship plucked him from the water, suffering badly from hypothermia.

More than half of those who had left Baltimore the previous afternoon perished in the sinking of *Express*. Fifteen crew and passengers survived, including Captain Parker. Sixteen people did not, with the final body—that of a young woman who had boarded as a passenger—washing ashore a few days later.

Today, we might ask the question: Could the loss of life have been prevented? Captain Barker might have trusted his instincts and not sailed that day, but he was keeping to the ship's schedule as ordered. How many of us have braved a snowstorm or bad weather to get to work out of dedication or the necessity of a paycheck?

Weather forecasting was still in its infancy, and little was understood about the paths of hurricanes. Even years later, in 1900, the failure to predict a hurricane at Galveston, Texas, would result in eight thousand deaths.

Could the ship itself have been to blame? Built in 1841, *Express* was an older steamer. Its owners had lengthened the vessel in 1872 to better accommodate passengers and cargo. It is possible that the alteration of the ship over the years resulted in a vessel that wasn't as strong as it could have been to withstand a Mid-Atlantic hurricane. Then again, *Express* had a reputation as a modernized and sound ship of two hundred feet, making it a fairly substantial size for the Chesapeake.

Ultimately, when the facts are weighed, it's hard to blame the *Express* tragedy on anything but the fury of one of the worst storms ever to strike Chesapeake Bay.

The Rise and Fall of the Peach Barons

Middletown, Delaware

The old mansion outside Middletown, Delaware, looks forlorn today as trucks and cars whisk past on their way to someplace else. Time has passed the stately house by, but for a dozen or so years in the late 1800s, when the paint was fresh and peach trees bloomed in the fields, it might very well have seemed like the center of a newfound empire.

Mansions like this still dot the landscape around the Delaware towns of Middletown, Townsend, Smyrna and Bridgeville. They serve as reminders of the peach boom, an era when fortunes were made and grand houses sprang up as symbols of the peach barons' new wealth. Even relatively small farmers made more money than

One of Delaware's last commercial peach orchards in 1922. By then, a mysterious disease called "the Yellows" had mostly wiped out Delmarva's peach boom. *Courtesy Delaware Public Archives.*

they ever dreamed possible raising corn and wheat. And then, almost overnight, the boom mysteriously ended.

Peach trees came to Delmarva in the earliest days of European settlement, possibly from Spain. The sandy soil and relatively mild climate made for ideal growing conditions, and small orchards dotted the farms and yards around the peninsula. It wasn't until 1832 that the planting of the first commercial peach orchard took place at Delaware City. By 1836, those 110 acres of fruit trees produced about $16,000 of peaches in a single season. Other farmers planted orchards, and thus began the biggest agricultural boom in Delmarva history. Advances in roads, shipping, railroads and canning suddenly made peaches a viable crop. And there was no better place to grow them than Delaware.

Delaware peaches were known for their "brilliant color, large size, luscious flavor and superb quality," stated G. Harold Powell of Delaware College, in delivering a paper entitled "Some of the Causes of the Decline in Delaware Peach Growing" before the Eastern New York Horticultural Society in 1901. He further credited good soil and nearby markets as contributing to the boom.

"The success of the new enterprise induced others to enter the peach-growing business and the next few years witnessed an era of the most rapid horticultural [enterprise] in the East," Powell noted.

New Castle County, Delaware, had three thousand acres in peach orchards planted by 1856 and shipped 500,000 baskets of fruit in

1848—a quarter of the crop was produced by a single farm family, the Reybolds.

Peach production spread to the area around Middletown, which quickly became the center of the peach industry not only on Delmarva but also in the world. Miles of the flat farmland around the crossroads town were soon planted in orchards. The heyday of the Middletown-Odessa-Townsend peach era was the 1870s, especially from 1875 to about 1880. A single farmer, Seerick Shallcross, planted 100,000 peach trees on more than one thousand acres and in 1871 sold 125,000 bushel baskets of peaches worth about $150,000—roughly $2.5 million in today's currency. Year after year, the profits rolled in.

During the harvest, huge numbers of workers were needed, and the orchard owners employed men, women, children, African Americans and Irish immigrant labor to pick the peaches. There was certainly no shortage of jobs; all hands were needed.

From the Middletown area, trains and "buy boats"—the floating tractor-trailer trucks of the nineteenth century—carried peaches to the cities or else to local canning factories that employed hundreds of people to pare, slice and steam the peaches for canning. At the Richardson and Robin cannery in Dover, workers processed up to 150,000 baskets of peaches every day to create a daily output of twenty-five thousand cans. Some of the crop went to make peach brandy. When there were just too many peaches, farmers fed them to the hogs or dumped them in the nearby Delaware River or Appoquinimink Creek in an effort to keep the market price up.

The peach boom attracted national attention, with journalist William C. Lodge writing about Delaware's orchards for *Harper's* magazine in 1870. "From Middletown to Townsend, where another peach train is waiting, the whole available country is planted with peach trees," Lodge wrote. "The ordinary farm crops appear to be neglected, while the labor is wholly devoted to gathering and marketing the fruit."

According to Powell's account, the peach boom caused land prices around Middletown to soar. The value of a single acre doubled and then tripled over five years. But the peach crop seemed like the next big thing, so many farmers took out hefty mortgages to purchase more land to plant more trees. Grand three-story mansions with

multiple staircases sprang up across the countryside. Still others invested in canning facilities or in wagons and ships for hauling peaches. It seemed like an era of prosperity had finally arrived, and everyone wanted to be part of it.

Then, just as suddenly as the peach boom had begun, sweeping up so many in a wave of giddy optimism, disaster struck.

Trouble started when the leaves of the peach trees turned yellow across entire orchards. The trees sickened and died, leaving tons upon tons of developing peaches to wither. The mysterious disease came to be known as "the Yellows." Within months, the peach industry was in ruins.

At that time period, there was little understanding of what might be causing the Yellows. Farmers tried what they could, cutting down trees or pulling them up by the roots and then replanting the orchards. The diseased trees were buried or burned so that the telltale smoke filled the air that had once been scented only by peach blossoms. Unfortunately for the peach barons, their newly planted trees also caught the Yellows. It seemed that the soil itself had somehow become inhospitable to peaches.

The peach industry did survive to a certain extent. For reasons that weren't understood, orchards planted farther south in Delaware seemed to do all right. The orchards around Smyrna thrived for a while until the Yellows appeared there as well. By 1900, the peach industry was centered on Bridgeville in Sussex County and Wyoming in Kent County. Even as late as 1900, at least 4.5 million baskets of peaches were shipped by rail car from southern Delaware, according to the 1901 *Cyclopedia of American Horticulture*. The Yellows finally caught up with these orchards as well.

The boom was over for the Middletown area, though. Without a crop, farmers who had borrowed money to expand couldn't pay their mortgages and lost their farms. Individuals who had spent too freely in anticipation of the good times ahead went bankrupt. Never again would there be such a profitable crop, and it would be more than a century before the Middletown area recovered economically when it was reborn as a bedroom community for commuters.

It wasn't until the 1930s that agricultural scientists really came to understand what caused the dreaded Yellows. It was neither a

virus nor a bacterium; it was a "viroid," an organism that has some qualities of both. Scientists learned that the viroid that causes the Yellows is endemic to certain areas, existing in native fruit trees such as wild plums without causing them any harm. An insect called a leaf hopper serves as a vector, transmitting the disease from the wild trees to commercial orchards when it feasts on the peach leaves. Pesticides and removal of wild host trees near orchards helps to control the Yellows.

All of this knowledge came decades too late for Delmarva's peach barons. By then, the boom years were just a memory, honored when Delaware chose its official state flower—the peach blossom.

Delaware's Coin Beach

Even on the most windswept day at the Delaware shore, it's not that unusual to see a solitary treasure hunter making his way along the beach. Some are equipped with the very latest high-tech metal detectors that cost about $1,000, while others rely on nothing more than their own keen eyes. Most of the time, their "treasure" consists of loose change, lost keys and an occasional class ring left behind by the summertime beach crowd. Every now and then, though, they are rewarded with something far more special.

According to treasure hunters, beachcombers and historians, it's not all that unusual to find coins along the Atlantic beaches from New Jersey down to Virginia. However, there is one Delaware beach in particular that has become famous for the sheer number of coins that have washed up there. It's no wonder that this sandy spit between Fenwick Island and Indian River Inlet has earned the nickname "Coin Beach."

Why have so many coins washed up? Experts say it is because there may be hundreds of shipwrecks scattered across the depths of Delaware Bay.

In colonial times, Philadelphia was one of the busiest ports in North America, with ships from around the world coming and going. There were no adequate roads, so almost all goods and passengers traveled by ship. Unfortunately, the ships sailing to and from

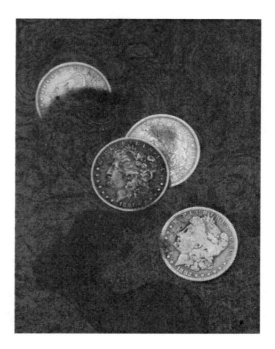

Coins still wash up on Delaware beaches, a reminder of the many colonial-era shipwrecks of vessels filled with gold and silver from the New World. *Author's photo.*

Philadelphia had to traverse Delaware Bay, which even today poses a challenge to navigation. The waters are rough, churned by strong winds, tides and currents, not to mention that storms blow in from the Atlantic. To make matters worse, Delaware Bay is notorious for its dangerous shoals. These sandy, shallow places are always ready to trap an unsuspecting vessel, where it can be battered by a storm. Imagine trying to navigate these waters in the days before radar and GPS, let alone decent maps or charts, and you get a clearer picture of why Delaware Bay has become a graveyard for so many ships. In fact, all one has to do is pay a visit to Cape Henlopen State Park and climb the submarine watchtower or the Great Dune to get a good vantage point of Delaware Bay. The shoals are clearly visible as brown or murky patches scattered around the blue waters. It quickly becomes apparent why there were so many shipwrecks here.

The most famous of these wrecks may be *De Braak*, a ship that had sailed under the Dutch flag before being captured and refitted by the Royal Navy as a two-masted, sixteen-gun sloop. On May

30, 1798, as the ship prepared to sail into Lewes harbor, it was struck by one of those freak storms that help make Delaware Bay so treacherous. A gust of wind caught the ship off guard and knocked it so far onto its side that the hatches filled with water. Within minutes, HMS *De Braak* had gone to the bottom, taking the captain, twenty-three crewmen and twelve Spanish prisoners with it. For years, the ship lay forgotten and undisturbed about one mile north of Cape Henlopen. Then, in 1985, a team of treasure hunters found the ship and its cargo of gold, worth millions of dollars today. They also found a more gruesome discovery—the remains of several sailors. According to an article by Peter Durantine in the *Wilmington News Journal*, these remains were given a proper burial on land.

It may not have been enough for the captain, however. The body of Captain James Drew washed ashore after the shipwreck and was buried at St. Peter's Episcopal Church in Lewes. But some say that Captain Drew still rises from his grave on stormy nights to roam the beach, searching for his lost ship. Others say that they have seen *De Braak* itself under full sail, its doomed crew crying for mercy. These tales seem hard to credit until one has strolled the beach alone on a stormy day…and wondered.

While *De Braak* may be the Delaware coast's most famous shipwreck, it is not the reason for the existence of Coin Beach. A few treasure hunters have reported finding coins that might be from the wreck of the *Three Brothers*, a ship that ran aground in 1775. The *Three Brothers* carried the payroll for British troops during the Revolutionary War. However, treasure hunters say that most of the coins have washed up from the wreck of the *Faithful Steward* in 1785.

According to Dale Clifton, director of the DiscoverSea Shipwreck Museum in Fenwick Island, Delaware, the beach and the wreck of the *Faithful Steward* still offer rich rewards, and he has collected many of these coins over the years.

On a stormy September night, the *Faithful Steward* was on the last leg of a voyage from Ireland to Philadelphia when disaster struck. The ship ran aground on a shoal near Indian River Inlet. Rough seas and high winds proceeded to tear the ship apart.

It was a terrifying and deadly mishap for the 249 people on board. Most were Irish immigrants, hoping for a new start in America.

All but 68 on board perished during the night. Legend says that townspeople in Lewes heard the terrified cries of the shipwrecked people and came to stand on the shore but were helpless to launch lifeboats in the darkness and storm. In the early morning light, the survivors realized that they were just one hundred yards from shore.

Besides passengers, the other cargo that the *Faithful Steward* carried was four hundred barrels of copper Irish half pennies, minted between 1766 and 1782, each coin bearing the likeness of King George III. Mixed in were a few gold guineas. Today, it's mainly these pennies that wash up on Coin Beach, especially after a nor'easter churns up the sand anew. While these eighteenth-century pennies weathered by sand and salt are worth no more than a few dollars apiece, it's really the tragic story behind them and the simple thrill of discovery that makes them valuable and Coin Beach worth a visit.

CANNIBALS ON ASSATEAGUE

Worcester County, Maryland

Of all the stories about early explorers and settlers on Delmarva, the voyage of the *Virginia Merchant* may be the most harrowing, if little known, real-life tale of survival on an island wilderness that could rival the adventure of Robinson Crusoe.

Unlike Daniel Defoe's famous character, who was stranded by a shipwreck, the settlers on Assateague Island were marooned by an act of treachery. Plagued by cold, hunger and wolves, the little band hung on as best they could just a short distance from where today they would find a resort city with saltwater taffy, boardwalk fries and pizza by the slice. By the time they were rescued, just a handful survived—and only because they had eaten the others.

The story begins without a hint of the horrors to come, when the *Virginia Merchant* set sail from England on September 23, 1649. The *Virginia Merchant* was a substantial vessel for its day, displacing three hundred tons and armed with thirty guns to fend off pirates. On board were 330 passengers who had paid six pounds each for the passage to Virginia.

Storm-tossed waves are captured in this vintage postcard view. The stormy seas around Delmarva resulted in more than a few shipwrecks. *Courtesy Historical Society of Cecil County.*

Among those passengers was Colonel Henry Norwood, an English adventurer who had joined with a group of acquaintances in hopes of experiencing what the New World might offer. Years later, about 1669, Norwood wrote a fifty-page account of what had taken place on that gruesome journey. The original document was studied by Dr. William H. Wroten Jr., who described its contents for a 1964 article in the *Salisbury Times*; it is now available from the Edward H. Nabb Research Center for Delmarva History and Culture.

Everything was smooth sailing, so to speak, as the ship crossed the Atlantic and arrived in the West Indies. When the *Virginia Merchant* left port again, its difficulties began. First, the ship and its passengers narrowly avoided being swept up in a giant waterspout off Bermuda. On November 8, 1649, as they approached Cape Hatteras—with their final destination of Jamestown not far off—a tremendous storm blew the ship far out to sea. To make matters worse, they were then caught by an even more vicious storm. According to Norwood's account, the ship then wandered about "lost at sea" for several stormy days and nights, with no stars or sun to navigate by, until the sky cleared enough for the captain to regain their bearings.

The storms weren't over for the *Virginia Merchant*, though:

The fury of the raging sea, tossed up and down without any rigging to keep the ship steady, our seamen frequently fell overboard, without any one regarding the loss of another, every man expecting the same fate...in many tumbles, the deck would touch the sea, and there stand still as if she would never (right herself).

This final storm did more than damage the ship—it soaked the supply of bread and other food intended for the passengers and crew. The ship had now been wandering at sea for days beyond its scheduled landfall, so the water supply ran out. Things began to look grim as Norwood described the food shortage that spread over the ship:

[T]he famine grew sharp upon us. Women and children made dismal cries and grievous complaints. The infinite number of rats that all the voyage had been our plague, we now were glad to make our prey to feed on...a well grown rat was sold for 16 shillings as a market rate...a woman great with child offered 20 shillings for a rat, which the proprietor refusing, she died...My greatest impatience was of thirst, and of dreams, were all of cellars, and taps running down my throat, which made my waking much the worse by that tantalizing fancy. Some relief I found very real by the captain's favor in allowing me a share of some small claret he had concealed...it wanted mixtre of water for qualifying it to quench thirst.

As it turned out, the rats would be nothing compared to what Norwood and some of his fellow voyagers were eventually driven to eat.

Fate seemed to take a turn for the better when land was sighted on the night of January 3, 1650. They had apparently arrived at the northern reaches of Assateague Island, which was uninhabited. The colonel went ashore with other "sickly passengers" in hopes of finding fresh water and perhaps an inlet where the ship could anchor.

"As soon as I had set my foot on land, I rendered thanks to almighty God for opening this door of deliverance to us," Norwood wrote, not knowing that by the next day, the island would not prove to be so welcome.

The captain and first mate also came ashore, and the captain shot a duck that made a feast for the hungry band. They spent the night on the island, hearing only the distant howling of wolves.

In the morning, as the band prepared to leave Assateague, the captain and first mate got an early start and started rowing back to the ship. They began to row even harder, and those left onshore were horrified to see why. The ship was leaving! The captain and first mate were close enough to catch up and were taken aboard, but those onshore could only watch as the *Virginia Merchant* gathered speed and disappeared, never to be seen by them again.

Thus began a winter of despair for Colonel Norwood and the other marooned passengers—a handful of men and three women. Due to his rank and social standing, Norwood became the de facto commander of the band. They put up one hut for the women and one for the men. Fortunately, they did have guns and were able to shoot some ducks to eat. But when the flocks disappeared, they were reduced to eating oysters and boiled weeds. Soon, winter tides and cold made the oyster beds unreachable, and the little band had nothing. They scarcely had the energy to collect firewood: "Thus we wished every day to be the last of our lives (if God had so pleased) so hopeless and desperate was our condition, all expectation of human succour being vanished and gone."

What happened next is so horrible to be almost unthinkable. In his own words, here is how Colonel Norwood described events:

> *Of the three weak women before-mentioned, one had the envied happiness to die about this time; and it was my advice to the survivors, who were following her apace, to endeavour their own preservation by converting her dead carcass into food, as they did to good effect. The same counsel was embrac'd by those of our sex: the living fed upon the dead; four of our company having the happiness to end their miserable lives on Sunday night the last day of January.*

Norwood and the few survivors were eventually rescued by a passing ship and finally taken to Jamestown.

One has to wonder, in reading Norwood's account, if he is revealing all that took place on the windswept island as the dead men and women became meals for the living. His story brings to mind the

disaster of the whaleship *Essex*, sunk by a whale in the Pacific Ocean. The crew escaped on lifeboats but wandered for months on the wild oceans, finally being forced to draw lots in regard to which of them would be killed and eaten by the others. Some of the few surviving crew sought to publicize their story years later—not in hopes of fame but rather to explain the necessity of eating their own because of the public horror over what they had done. It's likely that Norwood, who was of the gentlemanly class, also sought in his account of events to justify the gruesome meals served on Assateague.

Still, one can't help but wonder if the starving band might have helped some of the others toward becoming dinner? Colonel Norwood's grim tale remains the only documented account of cannibalism on Delmarva.

LIGHTNING CAUSES AIRLINE CRASH

Elkton, Maryland

One of the greatest tragedies to occur on Delmarva in sheer terms of loss of life took place on December 8, 1963, when Pan Am Flight 214 exploded in the sky over Elkton. Due to the unusual nature of the disaster, an air of uncertainty has always surrounded the incident. Was it an act of nature, or were more sinister forces at work? Some say that even today the unquiet ghosts of the eighty-one victims still haunt the area, as if they have questions of their own.

On the ground in Cecil County all those years ago, it was just another ordinary day as folks went about their business. It had, however, been an eventful few weeks, not just for local residents but for the nation. On November 22, President John F. Kennedy had visited to help cut the ribbon at the opening of a new high-speed interstate highway that came to be known as I-95. Less than a week later, local citizens who had met Kennedy and had been thrilled to shake his hand reeled from the news that the charismatic young president had been assassinated in Dallas.

Now, on this December night, Rosemarie E. Culley was working in the county's emergency dispatch center. The weather was

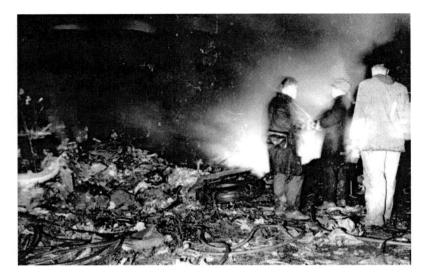

Investigators at the scene of Delmarva's worst air disaster, which took place in the skies over Cecil County in December 1963. Eighty-one people died in an accident attributed to a lightning strike. *Courtesy Historical Society of Cecil County.*

unseasonably warm and very windy, with a few rumbles of thunder overhead, which was unusual for that time of year. Otherwise, it had been a routine shift with not much going on except for the stormy weather.

All that changed in the blink of an eye. At 8:58 p.m., a frantic caller reported seeing a fireball in the sky over Elkton. More calls poured in as some people reported that not only the fireball but also debris was raining down from above.

On an eerie recording of the dispatch call, you can still hear Culley trying to sort out what has happened: "We have a plane crash…Eight fifty-nine…Route Forty just east of Swiss Inn… unable to advise the exact location," and a few minutes later, "it's on a farm…Delancey Road."

Carty Dennison, sports editor of the local weekly newspaper, recalled that he was driving on the new interstate when the fireball lit up the sky with such intensity that the automatic lights along the highway winked out as if the sun had suddenly risen.

Police and firefighters from all across upper Delmarva rushed into action, sending personnel and dozens of ambulances to the scene. Sadly, none of those ambulances would be needed.

All in all, until that moment, it had been an uneventful flight. According to the Federal Aviation Administration official report, Pan Am's Boeing 707 named "The Clipper Tradewind" took off from San Juan, Puerto Rico, at 4:10 p.m. and landed in Baltimore at 7:35 p.m. The jet then departed again at 8:24 p.m. for Philadelphia International Airport. However, due to high winds on the ground, the plane had been in a holding pattern, circling as it awaited its turn to land. Although the airport was an hour's drive away—even on the new interstate—it took a jet plane just a few minutes to cover that same distance.

Then, in what experts say is one of the most unusual aviation accidents known, the unthinkable happened. Cloud-to-cloud lightning from that rare December thunderstorm struck the jet. Experts who have since studied the accident have said that the result was an almost instantaneous explosion. Tragically, all that emergency personnel on the ground could do was pick up the pieces.

For the most part, burning debris from the jet fell onto a vacant cornfield just outside Elkton. Almost miraculously, no one on the ground was injured. If the debris had fallen just a short distance away, across the new interstate or onto the heavily populated downtown, the outcome might have been quite different.

Most have accepted the fact that lightning was to blame. Over the years, however, some haven't been as quick to believe the story. They point to the freak nature of the accident (almost fifty years later, this remains just the second verified case in which lightning caused a large passenger jet to go down). In fact, the *Guinness Book of World Records* still lists this accident as the "Worst Lightning Strike Death Toll."

However, coming on the heels of the Kennedy assassination and the theory that his death was the result of a plot, there has been some question that perhaps the loss of Flight 214 wasn't as straightforward as it seemed. Some have claimed that the explosion was caused not by lightning, but by a bomb, planted by the Central Intelligence Agency (CIA) to eliminate one of the passengers and something he carried on board the plane. With so many wild things going on during that era, could the passengers of Flight 214 really

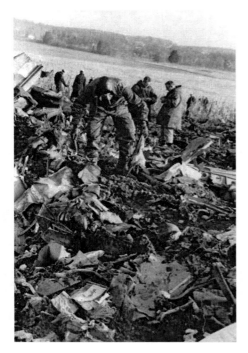

Debris from the crash rained down over a cornfield outside of Elkton, Maryland, that is now a housing development. *Courtesy Historical Society of Cecil County.*

have been the victims of some government plot? No proof, of course, has ever come to light.

Many relatives of those who died still visit the site and the Historical Society of Cecil County, which has a wealth of information about the crash, including a piece of the downed jet's fuselage. It's important to remember that for them, their lives have never been the same, some having lost parents and others loved ones.

Today, the cornfield where Flight 214 came down is an upscale housing development known as Turnquist. There is a marker that serves as a memorial to the seventy-three passengers and eight crew members who died in the sky above. Some residents here claim that they have seen the victims' ghosts over the years and have experienced other strange phenomena.

Rumors of ghosts and government plots aside, what we do know with certainty is that this jet explosion remains Delmarva's greatest tragedy in modern times, a terrible loss of life in the skies over Cecil County.

Part V

MONSTERS AND MYTHS

CHESSIE

Kent Island, Queen Anne's County

The great fish moved silently through the night water, propelled by short sweeps of its crescent trail. The mouth was open just enough to permit a rush of water over the gills...The eyes were sightless in the black, and the other senses transmitted nothing extraordinary to the small, primitive brain...

So begins one of the most terrifying "fish stories" of all time in the best-selling novel *Jaws* by Peter Benchley. That story, of course, was fiction, but it and its movie adaptation made a whole generation of beachgoers think twice about going into the water.

Fortunately for Delmarva beach enthusiasts, sharks and shark attacks are a rarity. In the last century, just a single shark attack has been reported at the Delaware shore. Sharks do cruise the Chesapeake Bay. While they aren't the great whites made infamous in *Jaws*, the bull sharks found in Chesapeake waters have been known to attack swimmers in other areas. Fishermen have caught ten-foot bull sharks under the Chesapeake Bay Bridge, and sizable bull sharks have been found as far up the Chesapeake as the Elk River in Cecil County.

But before you think you're off the hook, be aware that there may be another, more mysterious creature lurking in the waters of the Chesapeake. Over the years, after numerous sightings, this legendary sea monster has even been given a nickname: Chessie.

It would be hard to pinpoint when or where the legend of Chessie first arose. But according to Maryland's Department of Natural Resources, as early as 1936 the crew of a military aircraft flying over the Bush River reported spotting a large, reptilian creature in the water below. Ever since, there has been talk of some strange creature lurking in the waters of the Chesapeake.

Just about any body of water worth its salt has a sea monster. The most famous creature that comes to mind is the Loch Ness monster, or Nessie. Here in North America, the legend of Lake Champlain's creature, Champ, also has grown over the years and is similar in many ways to stories about the Chesapeake Bay's sea monster. In fact, there have been so many sightings, photographs and believers in Nessie and Champ that some amateur "monster hunters" and even professional cryptozoologists have dedicated much of their lives to searching for these monsters. Chessie doesn't seem to have the same following, but Delmarva's very own sea monster has been spotted often enough that the phenomenon can't be ignored.

At first glance, Chesapeake Bay might seem to have little in common with Loch Ness or even Lake Champlain. But all three have underwater geography that could harbor a sea monster. While Loch Ness is several hundred feet deep in places, and Lake Champlain reaches down as much as four hundred feet, the Chesapeake does have a few areas with depths of more than one hundred feet. And the Chesapeake has an outlet to the sea.

Like its more famous cousins, Chessie must either be very rare or very shy. You might easily spend your whole life on or near the water and never get a glimpse. Those who have seen Chessie, though, aren't likely to forget anytime soon.

The most famous sighting of Chessie took place in May 1982, when members of a Kent Island family, along with friends, spotted something unusual in the water and videotaped the creature. According to Maryland DNR, the publicity surrounding that event prompted a woman named Barbara Schulz to come forward

with a photograph she had taken of the creature. That summer, a symposium was held at none other than the Smithsonian Institution to discuss the photograph and footage. All that experts could say was that the creature was indeed alive.

Assuming that people aren't making up the sightings, and ruling out the possibility of some mythical beast, what possible explanation could there be for what they have seen? Some experts say it's possible that Nessie, Champ and Chessie might actually be plesiosaurs, prehistoric creatures long thought to be extinct. With its streamlined body, elongated tail and flippers, a plesiosaur closely matches many of the descriptions given by eyewitnesses. However, a plesiosaur has never been caught in modern times, and many doubt that such a creature could still exist without being identified or definitively photographed.

Another explanation is that many who have seen Chessie might actually be glimpsing a manatee. These large, homely and harmless "sea cows" are a more common sight in Florida, but on rare occasions they have gone off course and made their way into Chesapeake Bay. The most recent wandering manatee was, in fact, nicknamed "Chessie" and developed quite a following since he's begun roaming the Chesapeake about 1996. It's hardly a stretch of the imagination that an unsuspecting eyewitness who glimpses a manatee might think that he or she had laid eyes on Chessie. After all, it's thought that ancient mariners gave rise to mermaid legends after seeing a manatee (those poor lads must have been at sea for a long, long time).

Then again, the creature captured in the video footage at Kent Island was no manatee. That sea monster looked far more sinister, like a hunting serpent. Could Chessie, in fact, be a large snake? Some have theorized that a giant anaconda that hitched a ride in the ballast of a ship from South America may have jumped ship in the Chesapeake. It's also possible that the monster might be a Burmese python, like those that are now invading Florida's Everglades. Anacondas and pythons can grow to twenty feet or more and be about as thick as a man's thigh. The anaconda theory seems as good as any when it comes to explaining Chessie, but there is nothing all that reassuring about the thought of a giant snake prowling the bay.

In the end, we may have to accept that some things defy explanation, which might just be the case with Chessie. In fact, the legend of Chessie really isn't all that different from the fictionalized account of *Jaws*. It's a story that's entertaining by daylight or while sitting beside the pool. But if you are ever swimming in a secluded cove or taking a solitary stroll at the water's edge and you see something unusual in the water, you might experience a tiny but primitive tremor of fear at the back of your mind. Did you just have an encounter with Chessie? Don't worry; nobody would believe you, anyway.

OYSTER WARS

Crisfield, Maryland

Once plentiful, oysters are now considered something of a delicacy or rarity, mainly enjoyed raw on the half-shell by gourmands or else found lurking in the bottom of a bowl of seafood chowder. But in late nineteenth-century America, oysters were in far greater demand, almost a staple—and Chesapeake Bay was the best place on earth to find them.

You don't really "catch" an oyster. They grow naturally in great reefs or beds beneath the surface—at least they did in the 1800s and well into the twentieth century. All a Chesapeake Bay oysterman had to do was pick them up.

Oysters had existed for centuries, of course, in the waters of the Chesapeake. Some of the earliest European settlers survived by plucking them from the shallow water, and the Indians had always harvested oysters, as attested to by great piles of shells accumulated over thousands of years on Delmarva. But for the most part, oysters were a local food known mainly around the Chesapeake Bay.

The market for oysters changed dramatically just after the Civil War thanks to a couple of innovations. One was the development of "safety canning"—the same modern canning process we use today—that enabled oysters to be preserved quickly and in great numbers. (The same canning innovations would also fuel Delmarva's peach boom.) The second development was the spread of rail

Oyster tongers ply their trade on Chesapeake Bay during the 1800s. *Courtesy Library of Congress.*

transportation. Tracks laid to waterfront towns such as Crisfield and Cambridge meant rail cars full of fresh and canned oysters that could be shipped to Philadelphia and New York to be enjoyed by an increasingly affluent—and hungry—population.

Demand for oysters created a boom for Delmarva watermen. Unfortunately, it wasn't long before the oyster boom also brought violence and greed to the quiet Chesapeake Bay. Oyster wars broke out between rival watermen and between oystermen and government patrols trying to enforce oystering laws. In the fighting at a single choice oystering ground, Hog Island Flats, at least a dozen oystermen would be killed during the winter of 1884. All across the Chesapeake Bay, shots were fired, dead bodies washed ashore and the firepower involved escalated from pistols and shotguns to long-range rifles and even howitzers mounted on the boats themselves. Some waterfront towns installed cannons and militia patrols to protect their docks and harbors from the greediest oyster pirates.

To be sure, many of the watermen knew what they were in for, and some seemed to revel in the violence. It added excitement to the dull, hard work of oystering and made the rewards seem that much sweeter. But the darkest chapter of the oyster boom involved watermen who preyed on unsuspecting victims.

In the days before mechanization, oystering involved a great deal of physical labor. There were a couple of ways to harvest oysters. One was tonging, a practice favored by local watermen. Using long wooden tongs, an oysterman balanced himself in a small boat and grabbed oysters off the bottom. You could tell a tonger by his bulging arms, shoulders and neck—good men to steer clear of on a Saturday night in one of the waterfront towns. But tonging had its limits, and more industrious watermen—especially outsiders—favored dredging for oysters with a kind of rake that was pulled behind a wind-powered skipjack. It was heavy work that involved endlessly reeling a windlass to retrieve the oyster dredge.

To provide labor for their oyster dredge boats, unscrupulous captains might shanghai part of a crew. Unsuspecting victims—often naïve farm boys who had come to Baltimore looking for work—would find themselves drugged or plied with alcohol in a waterfront bar, only to wake up on board an oyster boat far from shore. New immigrants desperate for work were another frequent target, lured with promises of money that oyster captains never intended to pay. The winter waters were impossible to swim, and an oyster boat might stay out for weeks at a time. These shanghai victims provided slave labor and were often "paid off with the boom" in the end—knocked unawares into the icy water by the sweeping sailing boom. Unscrupulous oyster boat captains called these immigrants "Paddies"—a derogatory term for Irish immigrants—but they were just as likely to prey on the many Italian and German immigrants to Baltimore. It reached the point that "Paddy Shacks" sprang up in Dorchester County to hold immigrants prisoner until needed as crew on an oyster boat.

In his book *The Oyster Wars of Chesapeake Way*, John R. Wennersten relates a particularly troubling story about one such shanghaied crew in the winter of 1884. At the Baltimore docks, three young German immigrants were hired on a Somerset County oyster boat.

The promise of a paying job soon turned into a living nightmare. They found themselves subjected to brutal beatings, endless work and pitiful amounts of food. When one of the young Germans, Otto Mayher, became sick and unable to work, he was repeatedly beaten, tortured and finally murdered by the captain.

Captain Williams chose not to kill the two surviving men but finally left them ashore in Crisfield, penniless and far from home. As immigrants with few friends and no resources, it was a safe bet that they had little recourse against the cruel captain. Who would ever believe their story?

These men did not give up easily, though. They made their way back to Baltimore and sought justice until they found the ear of a sympathetic lawyer, Louis P. Hennighausen. Hennighausen was also a German immigrant whose hard work had made him quite successful. He was a skilled lawyer and a tough customer known for carrying a gun and defending the rights of German immigrants. He took his witnesses—and his pistol—to the Eastern Shore. After a brief trial, the oyster captain was found guilty of murder and sentenced to eighteen years in prison.

The two Germans were lucky to have survived their ordeal. Many others were not nearly so fortunate, with bodies frequently washing up onshore. The issue became so troubling that the Maryland legislature finally enacted tough new laws against it 1890. But for many unsuspecting young men far from home, whose drowned bodies turned up on the beaches, it was too late.

In the end, the oystermen proved too greedy for their own good. When state officials tried to enforce conservation efforts, they were fired upon by angry watermen. The oyster navy ultimately stripped Chesapeake Bay almost bare of oysters. In the twentieth century, poor water quality and disease all but wiped out the remaining oyster population.

While we might all be tempted to look with nostalgia on a time when oysters were easy pickings and the bay's waters were covered with tongers and dredgers, the reality of those times can't be ignored. Oystering was an ugly business that many paid for with their lives.

JAMES MICHENER'S *CHESAPEAKE* AND THE HOUSE FULL OF CANNED FRUIT

St. Michaels, Maryland

Legends and stories have a way of springing up around the more famous films and books about a region, and Delmarva is no exception, as we shall see when in comes to the best-known novel about the region. A number of movies have used Maryland's Eastern Shore as a backdrop, including Clint Eastwood's *Absolute Power*, filmed at Elk Neck State Park in Cecil County, and *The Wedding Crashers*, filmed in Talbot County.

Almost countless books have been written about or set on Delmarva, but the most famous by far is the novel *Chesapeake* by James A. Michener. This was the bestselling American novel of 1978, winning accolades such as "Michener's most ambitious work of fiction in theme and scope" from the *Philadelphia Inquirer* or simply "brilliantly written" from the Associated Press reviewer of the day. *Chesapeake* continues to be a strong seller today on Amazon.com and in bookstores all around Delmarva.

Michener is known for his sweeping historical sagas, and at more than eight hundred pages, *Chesapeake* makes as fine a doorstop as any of the author's books. And no wonder: the novel encompasses Delmarva history from the prehistoric days when the Chesapeake Bay was formed to the hot waterfront real estate market of the later twentieth century. In between, Michener introduces the reader to the earliest settlers and the drama of life on Maryland's Eastern Shore. For many readers, Michener's novels were a way to indulge what they felt was a guilty pleasure—reading fiction—because he infused his novels with so much information. A Michener novel entertains and edifies all at the same time.

As with all of his books, Michener undertook extensive research of the area, taking several years to explore the region, interview residents and delve into local history. By all accounts, Michener was a workaholic who spent exhausting amounts to time to make sure he got the details just right. When in the midst of writing a book, he sometimes spent twelve to fifteen hours a day in front of the typewriter.

When Michener arrived in Maryland to begin his research for *Chesapeake*, one of the first things he did was to seek out a modest home in St. Michaels to serve as his base of operations. This was a practice he followed whenever he researched a region for one of his novelistic sagas.

As related by some people who met him years ago during his exploration of the Chesapeake region, they found it hard to believe that they had just met the world-famous author whose books regularly sold millions of copies. He was a quiet but inquisitive man, intent on learning all he could about the people and the region. He was certainly no Hemingway, who left a boozy trail of adventures in his wake wherever he went. The wildest that Michener got was having crab cakes and a beer at the Robert Morris Inn in Oxford, Maryland. And yet the famous author had his quirks. One of the lesser-known facts about Michener is that he was a hoarder.

Michener grew quite wealthy from his writing. He owned part of the theatrical rights to *South Pacific*, one of the most popular musicals of all time and that is based on his first book, and he once stated that he could have lived quite comfortably for the rest of his life on the annual royalty payments he received from that production alone. Yet Michener wasn't all that interested in the trappings of wealth, except that money enabled him to work and travel. In fact, he gave away an estimated $100 million in his lifetime to philanthropic causes.

Curiously, though Michener was a millionaire who was in no danger of not knowing where his next meal might come from, he felt compelled to keep a supply of food on hand wherever he lived. But not just any food. For whatever reason, Michener hoarded canned fruit and juices.

His house in St. Michaels was no exception. Writing in *Michener and Me: A Memoir*, Michener's longtime friend Herman Silverman describes how the novelist would pile up cases and cases of canned fruit, leaving them stacked conspicuously in the homes he owned around the world. "When we visited Mari (his wife) and Jim at their apartment in Coral Gables or at the house in St. Michaels, there were cases—literally cases—of canned fruit sitting."

In his memoir, Silverman also describes how Michener, who was a boarder at the Silverman home and then frequent guest over

the years, often had nothing more than a can of peaches or other fruit for dinner. Peaches were his favorite, followed by pears and canned juices.

Certainly, Michener's compulsive stockpiling did not interfere with his work in any way, and it seems a harmless trait in a man who contributed so much to the world of history, arts and culture. Why did Michener hoard canned fruit? For a man who wrote so much over the years, he was curiously quiet on the subject.

THE HORSES THAT SWAM ASHORE

Assateague Island, Maryland, and Chincoteague, Virginia

Anyone who has visited the windswept beaches of Assateague Island has probably been captivated by the wild ponies there. Shaggy and smallish, these ponies are one of the island's main attractions. Like many wild animals, they are easy to glimpse but difficult to know.

Altogether, roughly three hundred ponies call Assateague Island National Seashore home. The national seashore straddles two states, and the ponies are naturally divided almost equally into two herds in Maryland and Virginia. They live in small family groups of between two and twelve ponies. These ponies are tough and hardy, having to endure fierce heat and swarms of insects in summer (not to mention crowds of campers and tourists) and bitter winds in winter. Then again, the ponies seem most at home when they have the barrier island mostly to themselves in the colder months.

A great deal of mystery and legend surrounds the origins of these ponies. No one knows exactly how the ponies got here or when. (Because there were no truly wild horses in North America, Assateague Island's animals were certainly brought here by early Europeans.) Like their cousins in spirit, the wild mustangs of the Old West, the wild ponies tend to be smaller than domesticated horses. One interesting fact about the ponies is that they drink tremendous amounts of water, leaving them with distended bellies. Why? Experts say the potbellied ponies have a diet high in salt, eating mainly salt marsh cord grass and beach grass. In short, the salty diet leaves them thirsty.

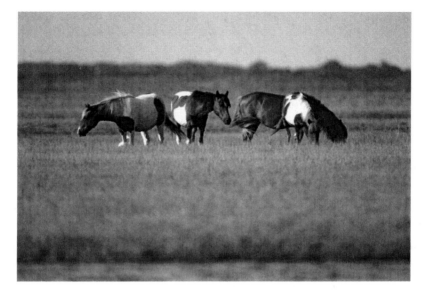

Wild ponies grazing on the marsh grass at Assateague Island. Many believe that the ponies are descended from survivors of a Spanish shipwreck that adapted to the harsh conditions on the island. *Courtesy Marc Clery.*

According to the National Park Service, it is most likely that the horses are descendants of animals that escaped from early settlers or else were set loose to graze on the island; settlers may have been trying to avoid taxes on the animals. Over time, these once-domesticated horses became wild. Several islands along the Atlantic coast also have populations of wild horses—though less famous than Assateague's—and these horses are all escapees from once-domesticated herds. Officially, the park service believes that these horses have been roaming the sandy beaches since the 1600s.

The more romantic explanation of their origin has to do with the legend of a wrecked Spanish galleon. According to this legend, a Spanish ship laden with gold and horses was wrecked during a storm just off the Virginia coast. Somehow, a few of the horses managed to swim ashore. The descendants of these survivors still live on Assateague today.

Could the legend be true? Shipwrecks were frequent on the shoals just off the coast, and not all wrecks have been documented or adequately mapped.

According to some sources, the wild horses can be traced to a specific ship, *La Galga*, a Spanish treasure ship that was shipwrecked on September 5, 1750, just off Assateague. Efforts to find any trace of this shipwreck have not been successful, but some now believe that shifting sands have actually left the galleon buried on the island itself. While some ponies do resemble mustangs, others look more like Welsh ponies or Arabians. Mustangs can be traced genetically to horses from Spain's Iberian Peninsula, but no genetic tests appear to have been done yet on the Assateague ponies.

The ponies might only be a curiosity known mainly to campers and park visitors if it wasn't for the perennial bestseller *Misty of Chincoteague* by the late Marguerite Henry. This 1947 children's classic tells the story of Misty, one of the wild ponies. The book won the Newberry Honor prize and was made into a movie. Generation after generation of children has been introduced to the legend of the shipwrecked wild ponies thanks to Henry's classic.

It's possible that no one will ever know the true origin of these animals. Does it really matter, though? When you see these ponies grazing among the marshes and dunes or wandering a solitary beach, it only adds to the air of mystery surrounding Assateague's wild ponies.

Part VI

GHOSTS, MURDERS AND MYSTERIES

HAUNTED HISTORICAL SOCIETY

Elkton, Maryland

Located at the top of Chesapeake Bay, Elkton is one of Delmarva's oldest towns. Captain John Smith first mapped the area in 1608 and named it "Head of Elk" for the resemblance the converging rivers on his map had to a rack of antlers. Nary a real-life elk was to be seen. Over the years, the name was shortened to "Elk Towne" and then finally "Elkton." The town became a busy crossroads in colonial times, with redcoats and Revolutionaries alike passing through. With a history stretching back four centuries, it's no surprise that Elkton has quite a heritage…and more than a few ghost stories.

One of the most well-documented haunted locations, ironically, is the Historical Society of Cecil County building. The three-story brick structure, painted a spectral white, occupies a stately location on Elkton's Main Street, across from the district court and almost next door to the Cecil County Courthouse. Located in the heart of Elkton, 135 East Main Street can be a busy place as history buffs come and go, as well as an arts-minded crowd involved with the Cecil County Arts Council, which also has its office and gallery

There is some debate over which ghost (or ghosts) roams the halls of the Historical Society of Cecil County on Elkton's historic Main Street. *Author's photo.*

located in the spacious building. A central feature of the building is the large staircase leading to the third floor.

The exact construction date isn't known, but the foundation was laid sometime in the second quarter of the nineteenth century. According to *At the Head of the Bay: A Cultural and Architectural History of Cecil County, Maryland,* the building was originally a bank. The first reports of ghostly activity seem to date from about 1955. The building was purchased that year for use as the county's public library. On occasion, a librarian might be alone and hear footsteps overhead. When she went to investigate, no one was there. Books sometimes toppled from the shelves for no good reason, almost as if someone had walked along and tossed them down.

Most unnerving of all, though, the librarians occasionally saw a shadowy figure walking among the stacks. When they tried to track him down, the man would simply vanish.

Ruth Ann Johnson was one of those librarians. Now retired after a long career at the library, she recalled the many odd incidents that seemed to indicate the presence of a benevolent ghost—or ghosts.

"There were nights when it was very quiet, and we did hear sounds on the staircase," she said. "Sometimes you could hear a dress swishing up the stairs. It's an old building, and over the years it has been many things."

Then there was the case of the disappearing chocolate bunny. About Easter, she said, someone brought in a chocolate Easter bunny, which soon simply disappeared from the lunchroom table. It was easy to blame such a small incident on a hungry coworker who wouldn't fess up. But the missing bunny seemed to launch an oddball chain of missing and moved objects that went on for years. Could there have been a mischievous poltergeist with a sweet tooth playing tricks on the library staff?

"We always felt as if there was a presence hanging around," said Johnson. "It's something that's hard to describe because you can't quite put your finger on it, but you realize that you are not exactly alone."

When the county library transferred to a new building in 1987, the incidents, and that nagging sense of being watched, didn't make the move.

These odd sights and sounds continued when the historical society took up residence. In fact, the number of curious incidents seemed to increase. Some visitors and volunteers, perhaps being more sensitive than others to an otherworldly presence, report that they become uneasy or even frozen with fear upon finding themselves alone on the second floor, where the society houses a museum filled with local artifacts.

This eclectic collection seems harmless enough...or is it? There are Civil War uniforms and swords, captured World War II Nazi uniforms, scraps of hair from dead presidents, vacant-eyed dolls and dresses worn by long-dead children. One theory put forth by amateur ghost hunters is that the historical society has inadvertently imported spirits that may be attached to these items of clothing, weapons and relics.

"Mirrors are especially known for harboring a spiritual presence," explains John Klisavage, owner of Washington Street Books and

Antiques in Havre de Grace, Maryland, and a collector of local ghost stories. "If someone has donated mirrors from their old houses, along with other objects, it's certainly possible that the particular spirit attached to that mirror or object is now occupying the historical society."

One mirror in particular, a massive mirror with an ornate gilt frame that dominates the second-floor landing, seems to put people on edge. Measuring about six feet wide and ten feet tall, the mirror radiates a creepy aura that defies explanation.

Recently, a group of amateur ghost hunters from Cecil Paranormal spent several hours in the historical society, seeking out a spiritual presence. First, they determined that a former slave cabin relocated to the property was definitely haunted. They moved on to the main building itself and were able to record a voice that seems to be saying "Shhh! The children must be quiet!" The voice isn't easy to detect, but you can hear it if you know what you are listening for. Could it be that the building is haunted by the ghost of some stern librarian?

Another theory about the historical society ghost has far older origins. The building is located next to the Dr. Mitchell House, built about 1769. Dr. Mitchell was a staunch Patriot during the Revolutionary War, opening his home for use as a field hospital for wounded Americans and redcoats alike after the nearby Battles of the Brandywine and Cooches Bridge. Not all of his patients survived, and some are likely buried on the property. Their graves may have been unwittingly disturbed when the historical society's building was put up more than 175 years ago. Some say it is the ghost of a dead soldier—or perhaps old Dr. Mitchell—who now wanders the building.

Some people are skeptical of ghosts (this author included, until a short time ago) and have yet to see or experience one. It may be that we skeptics see and hear what we want and simply close our minds to that which we don't accept as being possible.

The closest I have come recently to encountering a ghost has been alone at night among the boxes and shelves of artifacts at the historical society. As a member of the board of trustees, I'm there frequently and sometimes poke around in the upstairs storage areas.

Late one night in the winter of 2009, I was conducting research for this very book and was sifting through stacks of old newspapers in the "Bat Room" upstairs. (Yes, it's named for the winged visitors that sometimes pop up there.) When I had found what I needed, I took the crumbling newspapers to the artifact collection work area to photograph some of the pages.

As I worked, I kept experiencing the sensation that I was being watched. Unable to ignore the feeling any longer, I finally asked, "Is someone there?" and felt more than a little sheepish when there was no reply.

All around me were shelves filled with items out of the past: hand-carved wooden toys, posters from events held a century ago, crockery and record books filled with taxes and the bequeathments of the dead. It was dim up there under the flickering, pale fluorescent lights and cold enough to make my fingers stiff as I turned the pages. Almost on a whim, for no reason that I can think of, I aimed my digital camera out into the sprawling room and popped the flash. I hurried through the rest of my research, returned the newspapers and went downstairs. As I turned off the lights behind me, I'll admit I was feeling more than a little relieved to see familiar faces at the computers or sorting boxes of photographs that had recently been donated.

Much later that night, when I returned home, I opened the photos I had taken of the old newspaper pages on my laptop computer. There was the photo I had taken of nothing in particular, just shooting into the room. To my surprise, I could make out some sort of blurry...*something* in the photo. A kind of hazy blob. It might only have been some trick of the air reflecting the flash, but with a shiver I recalled how I had felt that someone was watching me.

With the same impulse that made me take that photo in the first place, I deleted it. The photograph wasn't proof of anything, after all, but I won't forget that feeling anytime soon.

From the collective experiences and occurrences, it seems that there may very well be a ghost haunting the place. Or perhaps even several ghosts—carried in on historical artifacts or else the result of disturbing the Revolutionary War dead or, heaven forbid, the spirit of some stern librarian. By day, with the sun streaming through

the old leaded-glass windows, these make for amusing tales. But at night, alone with objects from one bygone era after another, the ghosts of the past seem very much alive at the Historical Society of Cecil County building.

THE MYSTERIOUS COSDEN MURDERS

Galena, Maryland

The crime took place on a dark February night almost 160 years ago, but to this day the Cosden Farm murders of 1851 remain the most brutal mass killing on the Delmarva Peninsula. Three men were eventually hanged before a crowd of thousands, but some say that the real killers were never caught.

Sometimes called the Kent County Massacre, the five murders took place at the remote Moody Farm near Georgetown Crossroads,

Delmarva's most brutal mass murder took place at this house in 1851. The house at the Cosden Murder Farm, as it came to be known, was torn down in the twenty-first century. *Courtesy Maryland Historical Trust.*

in the vicinity of Galena. Renting the farm was a respectable young family named Cosden. It was about 6:30 p.m. one Thursday, and William Cosden had recently come in from a day of work when he saw someone outside. Far from expecting trouble, Mr. Cosden went to see what the visitor wanted.

That's when the night erupted in gunfire. The killings unfolded in a brutal and methodical fashion. William fell almost instantly. The killers then shot his wife, Mary Ann, and daughter, Amanda. A relative, Rebecca Webster, was upstairs in bed recovering from an illness. She locked the bedroom door, but the killers broke in and shot her and then set the bed on fire. An African American woman, hired out to work as a servant, was working in the kitchen. She was shot but made it to a neighboring farm before she died. The Cosdens' nephew survived because the small boy hid inside the house once the killers started shooting and then escaped.

The crime today would be exactly the kind of random home invasion that grabs headlines, and the killings soon made national news. But why were the Cosdens targeted? They were neither poor nor wealthy, being a typical farm family. There didn't seem to be any grudges against them. Legend says that Rebecca Webster had recently come into some money, a story that descendants confirm. It's likely that rumors about the money were exaggerated locally and that the killers may have thought there was much more to be found.

News of the massacre spread like a firestorm across the countryside, spreading fear and setting off a massive manhunt for the killers. The governor of Maryland announced a reward of $1,000 for the killers, an amount that soon tripled. Even now, Kent County is a rural, tightknit community where neighbors look out for neighbors and many families are related. In the heart of an Eastern Shore winter, bands of angry, armed men patrolled the roads, questioning and arresting any stranger who seemed even remotely suspicious. Bit by bit, it came out that the killers had been hiding out in the Appoquinimink Woods, a massive forest that straddled the state line between that part of Maryland and Delaware.

One of those arrested was another young husband and father found on the road not far from where the Cosden family had been

slaughtered. The man was covered in blood, and the local posse didn't believe his story that he had been skinning muskrats.

Eventually, three men were put on trial for the murders, including the hapless muskrat trapper. The trial was open and shut, despite testimony from two of the accused that they did not know the trapper. The verdict was guilty, and the judge declared that the three should hang by the neck until dead.

According to Frederick Usilton's *History of Kent County*, the hanging on August 8, 1851, was a spectacle that brought eight thousand people to the county seat at Chestertown. Five steamers tied up at the wharf on the Chester River. People slept all night in tents to be there for the hanging.

Even Usilton seems to express some doubt in his account, writing that "three men were hanged for the murder of William Cosden and family, on the Moody farm." Yes, three men were hanged, but were they the killers?

For some, the story of the Cosden murders is just a frightening local legend. For others, like G. Scott Lawrence of Middletown, Delaware, it's a story that is still handed down from one generation to the next as family legend. The Cosdens are distant relatives, and he recalls growing up hearing stories about the crime.

He was able to visit the house and recalls going down in the cellar, where the bloodstains were still visible in the floorboards overhead. According to Lawrence, at least one of the bullet holes from 1851 had been carefully preserved in an upstairs wall.

"It was a moving experience to walk in the same room where your relatives had been murdered," he said.

Lawrence is one of those who think that at least one innocent man may have gone to the gallows. "He'd been out trapping and skinning muskrats, so he was covered in blood," Lawrence said. "They were so eager to catch the killers that they brought him in. But the other two men said they didn't even know him."

According to Lawrence, the thousands of spectators surrounding the gallows got more than they bargained for when one of the ropes snapped and the unlucky muskrat trapper fell to the ground. As the other two danced at the ends of their ropes above him, he was carried back up the gallows steps and hanged again.

Execution by hanging was an inexact science, which is why it is no longer done in modern times. Ideally, a man's neck snapped when he fell, and he died instantly. For others, death was a slower and more gruesome ordeal involving strangulation.

"His face turned purple, and he bit his tongue in half," Lawrence said. "It was truly grotesque and cruel, especially considering that in the end this last man probably had nothing to do with the crime."

Lawrence's doubts may be more than family legend. In an 1852 edition of the *New York Times*, there is an intriguing account of a killer being hanged in Philadelphia. In the article, it mentions that this man, Matthias Skupinski, also made a jail cell confession to his role in slaying the Cosden family almost exactly one year after the three hangings in Kent County.

Skupinski was a twenty-eight-year-old Polish immigrant and blacksmith by training who spoke no English. He claimed to have been involved in the revolt against the Polish king at Krakow in 1848 and was forced to flee the country when the revolution was crushed. Destitute, he bummed around Europe before "being given money" to travel to England and, eventually, Philadelphia. (One wonders if Skupinski was really "given" this money, or if he got it by other means.) Skupinski fell in with a band of robbers and was hanged for his role in the murder of a city jewelry salesman whose body was dismembered and dumped into the Schuylkill River.

In the winter of 1851, Skupinski told a priest, he was traveling between Philadelphia and Baltimore, looking for work along the way. Did his travels take him to Kent County? If Skupinski's confession is to be believed, perhaps he was one of the real killers. In any case, you have to wonder why anything but the truth would compel someone on his way to the gallows to confess to a crime for which three men had already been hanged a year before.

Other families occupied the farmhouse where the killings took place, and the place came to be known as the Cosden Murder Farm. Given its bloody history, it's no surprise that the farm never really thrived. In photographs taken over the years, the house always has a run-down, decrepit air—as if no one had the heart or the energy to fix the skewed shutters and slap on a fresh coat of paint. In 2007, the house was torn down—to the despair of local history buffs.

Kent County lost one of its most infamous landmarks, but the legend of the brutal murders had long since taken on a life of its own. In the end, it's not only the awful crime but also the mystery surrounding the Cosden Farm Murders that still captures Delmarva's imagination today.

Andrew Jackson's Duelist Meets His Match

Caroline County, Maryland

A quiet corner of Caroline County may or may not be the final resting place for one of early America's most notorious duelists. By some accounts, Charles Dickinson killed as many as twenty-one men with his pistol. His killing streak came to an end on May 30, 1806, down in Kentucky, when he challenged future United States president Andrew Jackson to a duel and was shot down in cold blood by the man who would come to be known as "Ol' Hickory."

It is hard to understand just what sort of man Dickinson must have been to fight so many duels. Was he trying to prove himself among the rough-and-tumble frontier aristocracy? Or was he simply a violent man who cloaked himself in the "code duello" to get away with murder?

Born in 1780 to a prominent family, it's likely that Dickinson gained his reputation as a crack shot thanks to a boyhood spent hunting and shooting on Delmarva. As a young man, Dickinson studied law under U.S. chief justice John Marshall and eventually moved to the Tennessee frontier to become a plantation owner, horse breeder and duelist.

Jackson and Dickinson seem to have run afoul of each other in a feud over a horse racing bet. Like Dickinson, Jackson was a hard-living man who enjoyed drinking whiskey, betting on horses and defending his honor from any perceived slight. The argument escalated as the two went about the early nineteenth-century equivalent of "talking trash." Friends were drawn into the fracas, and Dickinson even published a letter in the *Nashville Review* that accused Jackson in print of being "a worthless scoundrel...a poltroon and a coward."

The remains of duelist Charles Dickinson (or Dickenson as it was sometimes spelled) are thought to be located within this tomb in Caroline County, although some experts say that he is actually buried in Kentucky near the site of his final, fatal duel with Andrew Jackson. *Author's photo.*

Even that might have been smoothed over before it came to violence, but legend says that Dickinson went too far by insulting Jackson's beloved wife, Rachel. Jackson's marriage was a touchy and sometimes scandalous subject because the couple had unwittingly committed bigamy—Rachel was not officially divorced from her first husband. (In the early 1800s, divorce was almost unheard of, and the sanctity of marriage was taken more seriously than today.)

According to an account of the duel in *American Lion: Andrew Jackson in the White House* by Jon Meacham, Jackson declared to friends that even if Dickinson left town, "It will be in vain, for I'll follow him over land and sea."

Jackson was a duelist in his own right, having engaged in somewhere between five and one hundred duels. He was not one to back down from a fight, to the point that at least one Jackson biographer went so far as to call the future president "unbalanced."

Even so, Jackson realized that he was facing an experienced and deadly opponent and took certain precautions. At six foot one and just 140 pounds, Jackson was exceedingly lean. He purposely chose to wear a bulky, oversized coat to make him appear larger. Jackson was also careful to stand so that he was sideways to Dickinson, thus presenting a narrower target.

The two men met each other across the state line in Logan County, Kentucky, because dueling was outlawed in Tennessee. Witnesses say that it was just after sunrise, with the morning mist swirling around the two men as they faced each other.

The duelists stood back to back and then stepped off twenty paces, as arranged, before turning and firing. Dickson reportedly whirled around and snapped off his shot almost immediately. At that range, it was hard for someone as skilled as Dickinson to miss. And yet Jackson still stood, his own unfired pistol pointing at the Marylander.

"Great God!" Dickinson shouted. "Have I missed him?"

Jackson pulled the trigger. Nothing happened. His pistol had misfired.

That might have been the end of it. The two men had fought their duel and could by the standards of society retire with their honor intact.

Jackson, however, demanded the right to reload since his pistol had not actually fired. And so, as Dickinson stood there and waited, the pistol was recharged, and Jackson took aim again. Dickinson must have been a man of steely courage not to move.

This time, the pistol fired. The ball struck Dickinson in the abdomen. A doctor on the scene declared the wound fatal, but Dickinson would spend hours dying in agony.

The Marylander had been so certain of his aim, and moments after Dickinson lay dying, it became clear why. A bystander noticed that Jackson's boot was filling with blood. Dickinson's shot really had hit Jackson, striking him right over the heart. The bullet was deflected by his ribs—and perhaps by that baggy coat—and now was lodged in Jackson's chest. Blood was running all the way down his body.

Yet Jackson had not so much as flinched. "If he had shot me through the brain, sir," Jackson later said, "I should still have killed him."

In those days of limited medical knowledge, doctors could neither save Dickinson nor safely remove the bullet from between Jackson's ribs. The lead ball stayed with him all the rest of his days, contributing to lifelong health problems, a painful reminder of his duel with Dickinson.

The duel is well documented, but its aftermath became hazy over time. Jackson, of course, went on to great fame. It's less certain what became of the man he killed.

Back in Maryland, a legend arose that Dickinson's body was taken back to Caroline County in a lead coffin, accompanied by an enslaved woman who had apparently been the handsome and dashing duelist's lover. The fact that a historical marker was placed near the site of Dickinson's grave seemed to make this so.

A *New York Times* article recounts how, in the 1960s, historians found a coffin in a Caroline County cemetery that seemed to verify this legend. However, tests conducted in 1965 by Smithsonian Institution experts showed that the bones were probably those of a woman.

Other accounts indicated that Dickinson was actually buried at Peach Blossom, his father-in-law's plantation near Nashville. That grave was long since lost, until archaeologists in August 2009 claimed to have found it in someone's front yard in what is now a housing development. According to media reports, any physical remains had vanished, but what was left of the coffin and grave site were to be reburied in the Old Nashville City Cemetery.

Ultimately, we may never know where Dickinson came to rest. Certainly, even if his body was buried in Tennessee, it's likely that his heart belonged to the rural Caroline County where he spent his childhood and youth. His fate remains an intriguing historical mystery.

In any case, history seems to have unfolded with or without the contributions of Charles Dickinson. But what if Andrew Jackson had been the one killed attempting to satisfy his honor? Would the British have won the Battle of New Orleans in 1815? The United States as we know it might not have survived a British victory during the War of 1812. There would have been no Jackson presidency. It's also likely that there would have been no Trail of Tears, a

tragedy for the Cherokee people that was brutally championed by President Jackson.

Ultimately, the real question is not who is in Dickinson's supposed Caroline County grave but how things might have turned out if Dickinson's bullet had hit harder or been an inch closer to Andrew Jackson's heart.

SEARCHING FOR BLACKBEARD'S TREASURE

Delaware shore

It's a fact, not a legend, that pirates roamed Delaware Bay at will during the late 1600s and early 1700s, terrorizing coastal Delmarva residents and wreaking havoc on merchant ships.

Delaware Bay in the seventeenth and eighteenth centuries was a rich hunting ground for pirates because of the merchant ships coming and going from Philadelphia and Old New Castle. There were also plenty of lonely beaches and windswept dunes for hiding the pirate's booty. The many winding marsh rivers made perfect pirate hideouts.

The original Delaware Bay pirate was Captain Kidd. Born about 1645 in Scotland, Kidd was a successful merchant in Manhattan before turning pirate. Kidd's ship *Adventure* cruised the Delaware coast in the late 1600s. He sometimes visited Lewes, and rumors persist that he buried a treasure chest at Cape Henlopen sometime in 1700 as the law closed in on him. Kidd was captured and hanged for his crimes in 1701.

While Kidd was infamous in his day, the best-known Delaware Bay pirate was Edward Teach—the dreaded Blackbeard.

Born about 1680, Blackbeard's origins are as ephemeral as sea fog. He may have been from London or Bristol, England, or even from Philadelphia. Historians aren't even sure that his name really was Edward Teach. However, the record is strong regarding his pirating activities.

Buccaneers such as Blackbeard often relied on intimidation and fright to overwhelm well-defended merchant ships. Blackbeard

Blackbeard was notorious and much feared along the Delaware coast. Legend says that he hid some of his treasure here, where it is still waiting to be found. *Courtesy North Carolina Museum of History.*

was a master of the technique. His nickname comes from the long beard plaited into braids and tied with ribbons. When attacking at night or in the sleepy hours of dawn, he placed burning fuses in his hair so that they poked out from under his fur hat, making him even more frightening.

Blackbeard's actions lived up to his appearance. He once chopped off the hand of a passenger who refused to give him a ring, and once made another hapless soul eat his own ears. It's even said that he would sometimes shoot his own men for no reason at all—other than to keep the other pirates in line.

In the early 1700s, Blackbeard terrorized the seas from Connecticut to the Carolinas, with Delaware Bay being one of his choicest hunting grounds for fat merchant ships. He commanded a forty-gun ship named *Queen Anne's Revenge*, which he had captured in a

sea battle. With the biggest pirate ship ever to sail, and accompanied by a flotilla of other pirate vessels under his command, he even took on the likes of the Royal Navy, defeating a thirty-gun man-of-war near Barbados.

Why did he spend so much time on Delaware Bay? It might have had something to do with the fact that his first mate and sailing master, Israel Hands, was from Cape May and knew the shoal-filled Delaware well. Also, the busy port of Philadelphia lured pirates the way blood draws a shark.

Blackbeard's method on Delaware Bay was to run out from shore in fast, shallow-draft boats and capture passing merchant vessels. (It's a tried-and-true tactic recently used even today by modern pirates off the coast of Somalia.) Blackbeard and his men then disappeared with their booty back into the shallow, marshy creeks where the authorities could not or would not follow.

For the most part, pirates weren't interested in carrying off a cargo of cotton bales or whale oil, which they would have trouble selling. A pirate was interested in short-term gain. Blackbeard's men would ransack a ship of its more portable valuables, such as the captain's china and silver, valuable navigation equipment, telescopes, food, rum and weapons of all sorts. In those days before international banking, passengers by necessity had to travel with much of their personal wealth and jewelry, so these especially made for a real pirate payday.

Pirates lent their names to some local landmarks. Kitts Hummock was almost certainly named for Captain Kidd. The greatest of Delmarva's pirate mysteries and legends, however, surround Blackbird Creek and the tiny village of Blackbird far up the waterway that winds through hundreds of acres of tidal salt marshes.

Historians say that the name "Blackbird" is actually a bastardized form of Blackbeard, who knew the marshes well and used them as a base for his raids into Delaware Bay. Pursuers were not eager to follow the pirates into the watery maze, knowing full well what might happen if they were ambushed or became so lost that they had to depend on Blackbeard's mercy to get out again.

It seems to be a perfect place to hide treasure, and legends say that Blackbeard buried some of his loot here. Nothing has ever been found—at least no treasure that anyone has made public.

Blackbeard may have planned to return someday to collect his treasure as a sort of retirement fund. But fate took him in another direction. In 1718, after spending several days meeting up with other coastal pirates on Ocracoke Island off the North Carolina coast for a buccaneer's bacchanalia, the pirates were attacked by a raiding force sent by the royal governor of Virginia.

Queen Anne's Revenge raked the attacking ship with a brutal broadside, and then the pirates swarmed aboard. But for once, Blackbeard had been tricked. Below decks, the Virginians' ship was packed with waiting men who surprised the outnumbered pirates. Blackbeard was shot five times and sliced and stabbed with cutlasses twenty times before finally falling. His head was placed on a spike at Hampton, Virginia.

That was the gory end of the Atlantic coat's most notorious pirate. But judging by the legends, perhaps something of Blackbeard's glittering legacy lingers today in the marshes of Blackbird Creek, still waiting to be found.

THE DROWNED TOWN

Conowingo, Maryland

Unknown to many motorists on Route 1 who cross Conowingo Dam at the very top of Delmarva, an entire town lies submerged under the deep waters of the Susquehanna River.

While only a handful of the two hundred or so former residents survive, the village of Old Conowingo hasn't been forgotten. Its history lives on in crumbling newspaper clippings, a few photographs and in the recollections of those who called it home.

Back in 1989, I interviewed eighty-four-year-old Curtis Ragan, a former Conowingo resident, about the lost town. Ragan's wife, Hazel, taught school in the two-room schoolhouse there, and his father had been the town doctor. The Ragans moved out in 1926 when Philadelphia Electric Company announced plans for a new hydroelectric plant that would harness the mighty power of the river that flowed past town.

Ragan recalled that there were thirty or forty buildings in town. In addition to homes, the town included a post office, a hotel, gasoline

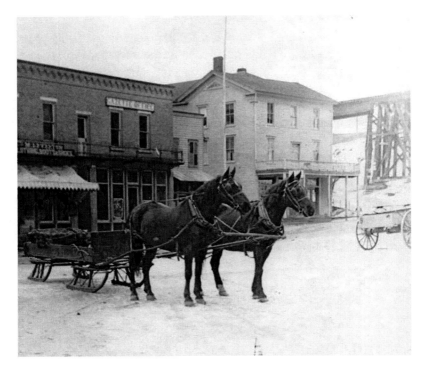

A team of horses waits to pull a sleigh through the snowy streets of Old Conowingo. The town and its buildings are now deep underwater. *Courtesy Historical Society of Cecil County.*

stations and grocery stores, as well as a railroad depot for the busy Columbia (Pennsylvania) & Port Deposit Line.

Ragan remembered that there were more than a few complaints about being forced out of a town in which generations had lived. "I guess there wasn't much they could do about it," he said.

The town's last day of existence was January 18, 1928. Police made a final sweep of the houses and buildings to make sure that no one lingered within. With Conowingo Dam in place, the rising waters of the Susquehanna began to back up through the streets.

The local newspaper reported, "Rising almost imperceptibly earlier in the day, the back flood gathered in force and by noon spread over flats and crawled up bluffs and back into creeks."

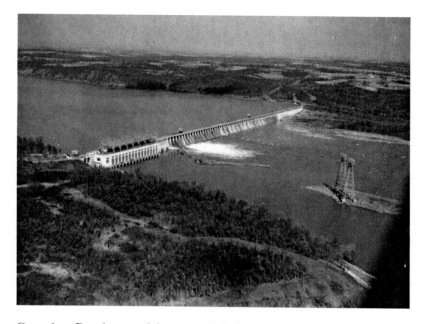

Conowingo Dam harnessed the power of the Susquehanna River, but its creation displaced an entire community. *Courtesy Historical Society of Cecil County.*

By evening, all that was left of Conowingo was a single roof visible above the rising water. When daylight returned, the town was gone.

Conowingo Pond, created by the damming of the river, would eventually submerge nine thousand acres and extend thirteen miles upstream. While the water nearest the dam is about 100 feet deep, there is also a mysterious and legendary whirlpool called Job's Hole, now hidden by the pond's waters. Job's Hole was located in the river near Old Conowingo. In 1922, engineers measured the abyss at 850 feet deep before their plumb line ran out.

Foolhardy as it may seem, some scuba diving enthusiasts have supposedly braved the muddy waters to explore the town below. Choked with mud and debris, at least some of the buildings are said to still exist underwater.

"It was a busy little town at one time, all right," Ragan recalled with a chuckle. "But you might just say that's all water over the dam at this point."

SELECTED BIBLIOGRAPHY

INTERVIEWS

Diggins, Milt. Interview about Thomas McCreary, February 16, 2010.

Johnson, Ruth Ann. Interview about Haunted Historical Society, February 5, 2010.

Lawrence, G. Scott. Interview about Cosden Murder Farm, January 18, 2010.

MAGAZINE AND NEWSPAPER ARTICLES

Bourne, Joel K., Jr. "Blackbeard Lives." *National Geographic* (July 2006).

Emery, Theo. "Killed in a Duel, Then Lost in the Earth." *New York Times*, December 17, 2007.

Healey, David. "Delmarva Architecture." *Delmarva Quarterly* (Fall 2009).

————. "Pirates of the Delaware: The Curse of the Black Flag." *Out & About* magazine (September 2003): 15–18.

Raccuglia, Regina. "Archaeologist Says He Found Remains of Charles Dickinson's Coffin." WSMV Nashville TV station, August 10, 2009.

BOOKS

Arnett, Earl, Robert J. Brugger and Edward C. Papenfuse. *Maryland: A New Guide to the Old Line State*. 2nd ed. Baltimore, MD: Johns Hopkins University Press, 1999.

Brugger, Robert J. *Maryland: A Middle Temperament (1634–1980)*. Baltimore, MD: Johns Hopkins University Press, 1988.

Chappell, Helen. *The Chesapeake Book of the Dead*. Baltimore, MD: Johns Hopkins University Press, 1999.

Corddry, Mary U. *Maryland's Eastern Shore: A Guide for Wanderers*. Chestertown, MD: Literary House Press of Washington College, 1997.

Footner, Hulbert. *Rivers of the Eastern Shore*. New York: Holt, Rinehart and Winston, Inc., 1944.

George, Christopher. *Terror on the Chesapeake: The War of 1812 on the Bay*. Shippensburg, PA: White Mane Books, 2000.

Healey, David. *1812: Rediscovering Chesapeake Bay's Forgotten War*. Rock Hill, SC: Bella Rosa Books, 2005.

Keathley, J.K. *Place Names of the Eastern Shore of Maryland*. Queenstown, MD: Queen Anne Press, 1987.

Meacham, Jon. *American Lion: Andrew Jackson in the White House.* New York: Random House, 2008.

Rollo, Vera F. *Maryland Personality Parade.* Vol. 1. Lanham: Maryland Historical Press, 1970.

Shomette, Donald G. *Lost Towns of Tidewater Maryland.* Centreville, MD: Tidewater Publishers, 2000.

————. *Shipwrecks on the Chesapeake.* Centreville, MD: Tidewater Publishers, 1982.

Swisher, Joe A. *The Complete Guide to Maryland Historic Markers.* Baltimore, MD: Image Publishing, 1996.

Wennersten, John R. *The Oyster Wars of Chesapeake Bay.* Centreville, MD: Tidewater Publishers, 1981.

WEB RESOURCES

A&E Television Networks. "Patriot and Future President Andrew Jackson Kills Charles Dickinson." This Day in History: May 30, 1806, http://www.history.com/this-day-in-history/patriot-and-future-president-andrew-jackson-kills-charles-dickinson.

Cook, Ebenezer, "The Sot-weed Factor." Introduction by Arthur Kay, http://theotherpages.org/poems/cook03.html.

Logan County Tourist and Convention Commission (Kentucky). "The Jackson/Dickinson Duel," http://www.visitlogancounty.net/default.aspx?cityID=2&subsection=false&itemid=39.

Nagle, George F. "Kidnapping and Murder: How the Rachel Parker Case Galvanized Pennsylvania Popular Opinion Against the Fugitive Slave Law." A paper presented at the first annual Underground Railroad Conference, Temple University,

Philadelphia, February 13, 2004, http://www.afrolumens.org/ugrr/parker.html.

The Women of the Maryland Women's Hall of Fame. Maryland State Archives, December 2009, http://www.msa.md.gov/msa/educ/exhibits/womenshall/html/whflist.html.

ABOUT THE AUTHOR

David Healey is a native Marylander who often writes about the people and places of the Delmarva Peninsula. His articles have appeared in *American History*, *Chesapeake Bay* magazine, *Chesapeake Life*, the *Washington Times* and *Delmarva Quarterly*. He is also the author of *1812: Rediscovering Chesapeake Bay's Forgotten War* (Bella Rosa Books) and a Civil War novel, *Sharpshooter* (Penguin Putnam). A graduate of Washington College in Chestertown and of the Stonecoast MFA program, Healey lives with his wife and two children along the Chesapeake and Delaware Canal in Cecil County, Maryland. In his spare time, he enjoys running, working on his old house and driving his family crazy by pulling over to read historical markers at the side of the road. Visit him online at www.davidhealey.net.

Visit us at
www.historypress.net